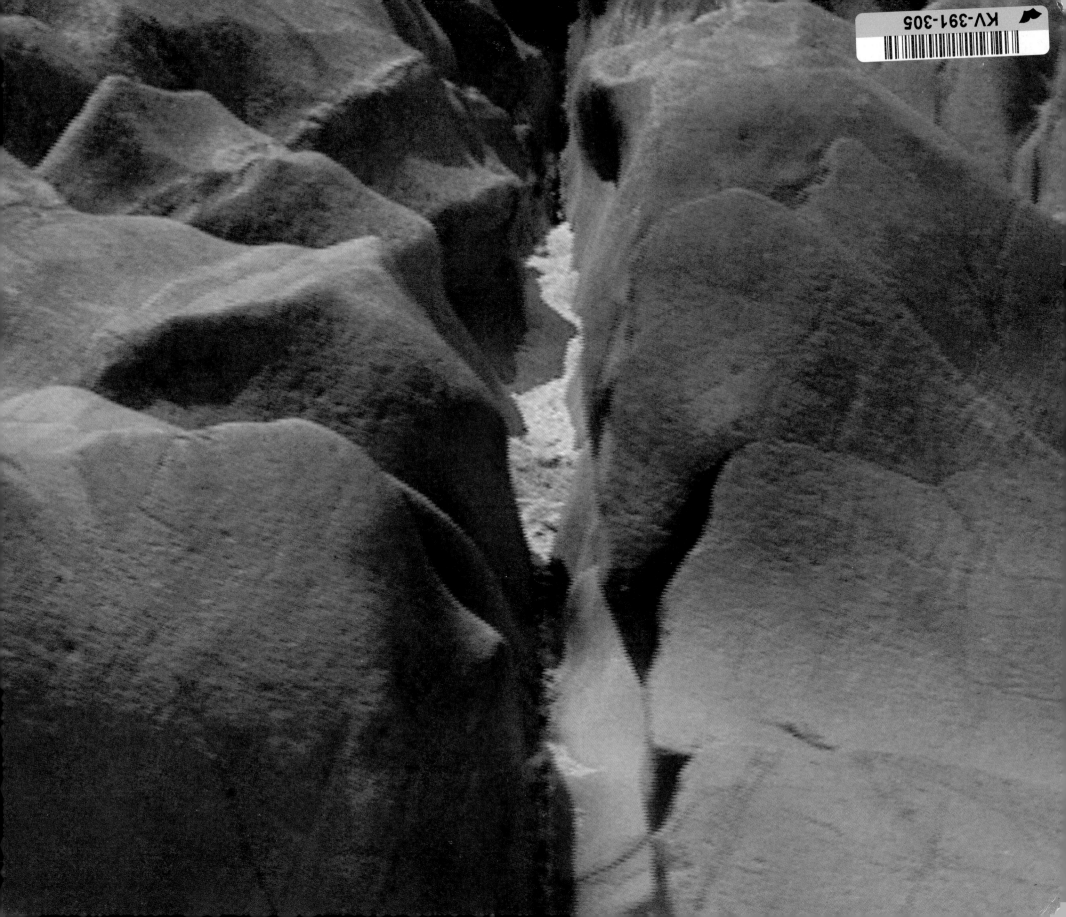

This catalogue is published to accompany the exhibition
Willie Doherty: Somewhere Else, 29 August – 4 October
1998 organised by Tate Gallery Liverpool.
Published by Tate Gallery Liverpool in association with
the Foundation for Art & Creative Technology (FACT).
Distributed by Tate Gallery Publishing, Millbank,
London SW1P 4RG

Designed by Herman Lelie
Typeset by Stefania Bonelli
Printed by Uwe Kraus GmbH

ISBN 1-85437-278-5

Photographs provided by:

Matt's Gallery, London and Alexander and Bonin, New York

Photographic credit:
Edward Woodman (p 23)
Mimmo Capone (p 30–31)
Brian Forrest (p 17)

770.92 DOH

The exhibition includes a new video installation *Somewhere
Else* 1998 commissioned by the Foundation for Art and
Creative Technology and funded by the National Lottery
through the Arts Council of England and the Henry Moore
Foundation in association with the 9th International
Symposium of Electronic Art (isea98).

SUPPORTED BY
THE NATIONAL LOTTERY
THROUGH
THE **ARTS COUNCIL**
OF ENGLAND

Cover image: **The Fence** 1996

Willie Doherty

Somewhere Else

Tate Gallery Publishing

Preface

Willie Doherty's photographs were first exhibited in the early eighties. Since that time his practice has changed and developed to encompass video. The source and inspiration of much of Doherty's work has always been history and place in his native Northern Ireland. Across the water the universal themes and issues which many of his works address have an additional poignancy at this time.

During the past decade Doherty's art has been shown throughout the world. This exhibition is timely because it gives us the opportunity to reassess the substantial body of Doherty's work. His understanding of the political and psychological uses of the tools of documentary reportage imbue the works with enormous potency.

This exhibition brings together a selection of works from the 1980s and 1990s and includes a new commission, *Somewhere Else*, from which the exhibition takes its title. Doherty's earliest black and white images with text are interspersed amongst the large scale vibrant cibachromes of the 1990s chronicling specific moments and incidents; a panoramic view of Derry, a detail of tyre marks. The images contain a particular and quite peculiar sense of time – neither fast nor slow. In the video works, this sense of time is heightened. Rather like the structural devices of which crime thrillers make use and from which Doherty borrows, the pace quickens then slows down. The commission *Somewhere Else* marks an exciting new departure in Doherty's work. A retrospective character is suggested by the use of images which have been seen in previous works.

Tate Gallery Liverpool is delighted to present this exhibition and to collaborate with the Foundation for Art and Creative Technology on the new commission which has been produced with the financial support of the National Lottery through the Arts Council of England and the Henry Moore Foundation. The exhibition coincides with revolution98 for the 9th International Symposium on Electronic Art and has been made possible through the generous support of the Tate Friends Liverpool.

We are indebted to all the institutions and individuals who have generously loaned works to the exhibition and in particular Galerie Jennifer Flay in Paris, Kerlin Gallery in Dublin and Alexander and Bonin in New York. We are very grateful to Robin Klassnik of Matt's Gallery in London who has provided unstinting support for the project and to Katrina Brown, formerly a curator at Tate Gallery Liverpool, for her work on the exhibition in its initial stages. Ian Hunt spent a considerable time talking to the artist before producing this illuminating and thought provoking essay. Finally, our special thanks go to Willie Doherty who has given his time, energy and enthusiasm to the planning, organisation and presentation both of the new commission and the exhibition.

Lewis Biggs
Director
Tate Gallery Liverpool

Eddie Berg
Director
Foundation for Art and Creative Technology

Introduction

Willie Doherty lives and works in Derry, Northern Ireland. A place already familiar as a hot spot of 'the Troubles' in Ireland and which has been directly and indirectly the focus of Doherty's work since the mid-1980s. This exhibition brings together a significant body of his work and provides a unique insight into how he has dealt with issues concerning the representation of place and the language of conflict. It concentrates on that area of Doherty's practice which affords a dual perspective, a parallel and equivalent presentation of two points of view.

In the earliest work included in the exhibition, this duality was in some ways achieved through the application of text to black and white photographs of Derry. In these works Doherty appropriates the stable journalistic tools of the photograph and caption, subverting them by combining his photographic images of rural and urban Ireland with the language of political conflict and idealism in works like *The Walls* (1987) and *The Other Side* (1988).

The presentation of two views in one work is further explored in Doherty's use of the diptych format in works like *Fog Ice/Last Hours of Daylight* (1985), *Stone Upon Stone* (1986) and *Small Acts of Deception I* (1997). In these works the artist combines two voices, revealing the tension between the visible and the hidden. This duality positions the work in the gap between the real experience of living in a place and the representation of it to the outside world.

The role and position of the viewer is important in Doherty's work. His photographs often employ a frontal low angle perspective which, coupled with the low hanging of the works, reinforce a simulation of the original relationship between seeing and being seen. For example his colour photograph *Critical Distance* (1997), a twilight view across Derry is taken from the vantage point of a surveillance camera. His images of disused warehouses and abandoned homes as in *Abandoned Interior I* and *II* and *Disclosure I (Restricted Access)* (1996) exploit this relationship to produce a direct confrontation between the viewer and the subject.

In other works the viewpoint shifts to macro close up and results in a loss of context from the bigger picture. In *Bullet Holes* (1995) and *Uncovering Evidence that the War is Not Over I* (1995) there is an absence of the related overview, which frustrates the attempt to locate the true objective reality from which the images are derived. This absence results in the inference of unknown and unknowable acts of violence and destruction, whilst simultaneously the abstract beauty of the images draws the viewer to the works.

In his use of high gloss cibachrome paper for his colour photographs mounted on aluminium Doherty makes it impossible to ignore the surface quality of these works. He exposes the medium as a highly coded and considered means of capturing situations, events or residues rather than a transparent window on the world. Our own image is reflected on the surface of the work. In *The Fence* (1996) this effect is further emphasised by the subject of the work where a physical barrier becomes a visual barrier in the photograph. This prevents us from seeing beyond or behind it, denying our attempts to enter the picture plane.

Doherty adopts related strategies within his audio-visual work to leave the viewer on uncertain ground. In *Tell Me What You Want* (1996) we observe a still image of a man's face and hear a conflicting set of messages, always spoken in a monotone voice. In his video projection works like *At the End of the Day* (1994) and *Somewhere Else* (1998) the experience is related to entering a cinema or watching a film in a dark space. However the viewer in Doherty's work is not a passive spectator, but is confronted directly by the control of his or her physical movement around the space. Doherty never defines a fixed viewing point and never allows a single narrative to evolve. In these ways he places the viewer in a gap between reading and understanding.

These preliminary observations highlight the duality and ambiguity of Doherty's work. A discussion of Doherty's most recent work *Somewhere Else* and an in-depth contextual analysis of the artist's concerns follow in the illuminating essay by Ian Hunt.

Camilla Jackson

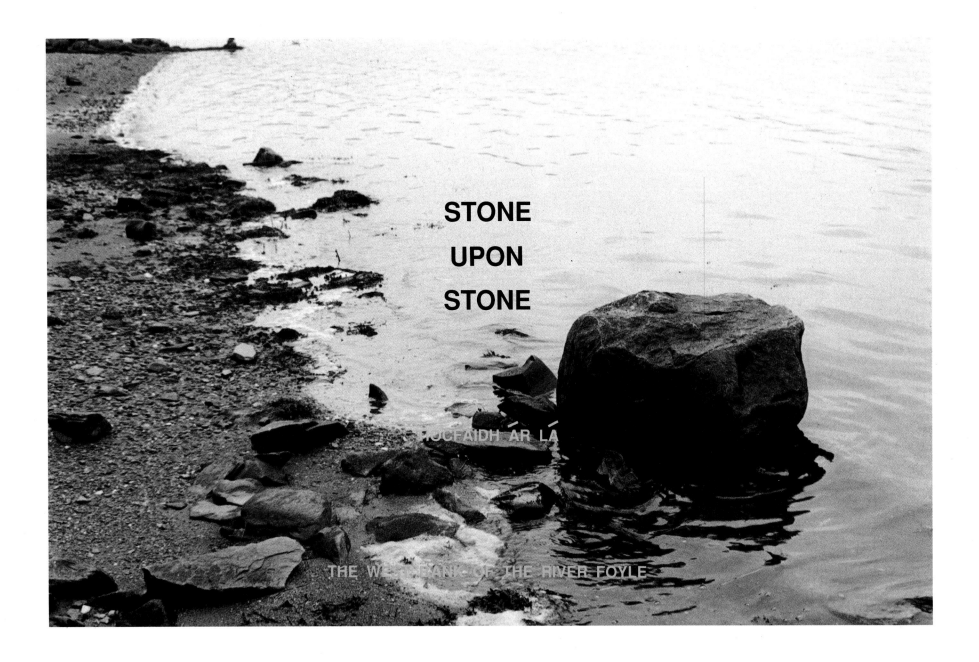

Stone Upon Stone 1986

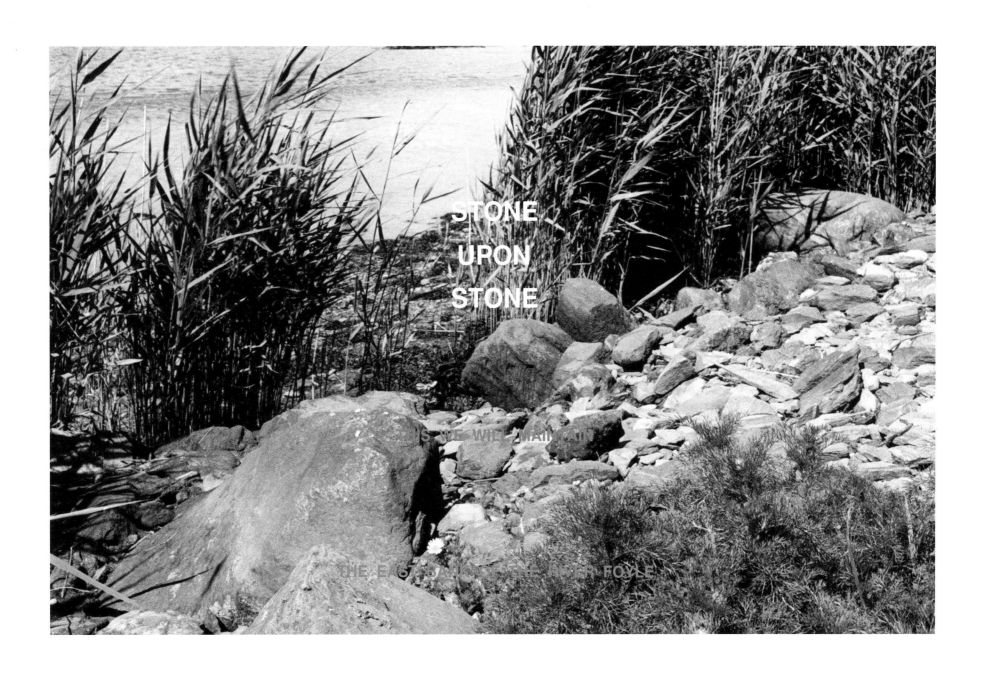

STONE
UPON
STONE

STONE WILL MAINTAIN

THE EAST BANK OF THE RIVER FOYLE

Critical Distance 1997

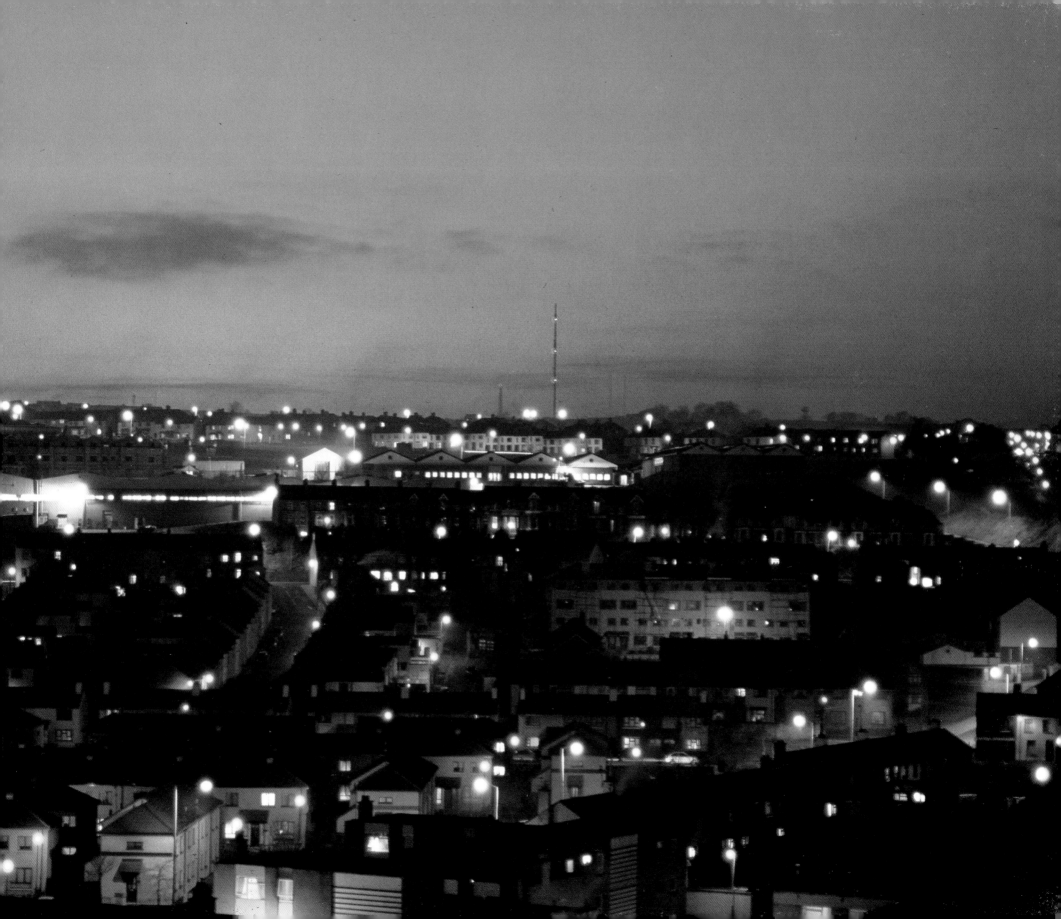

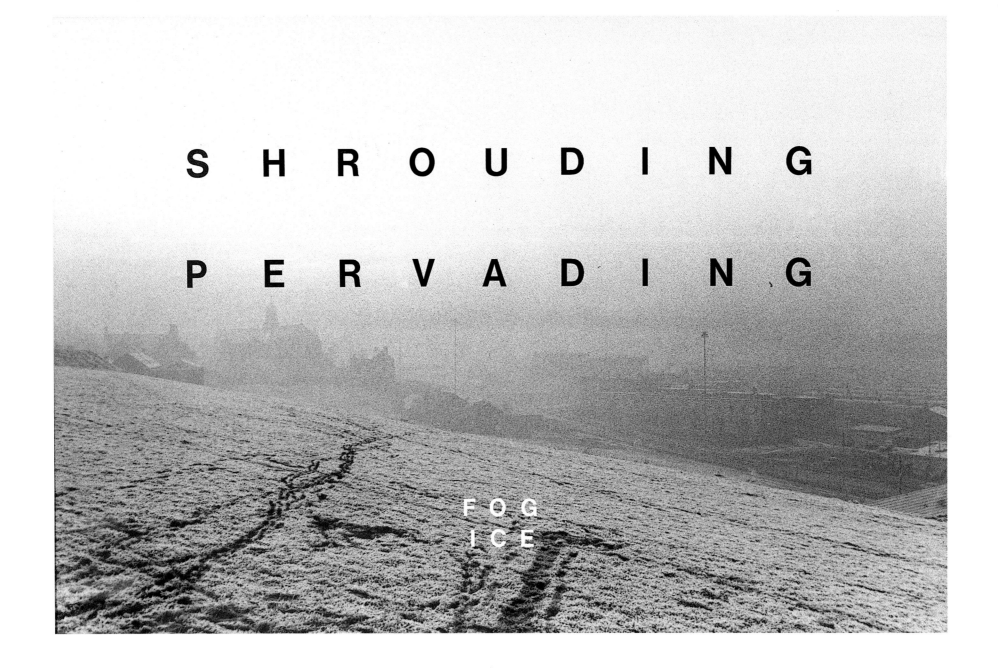

Fog Ice/Last Hours of Daylight 1985

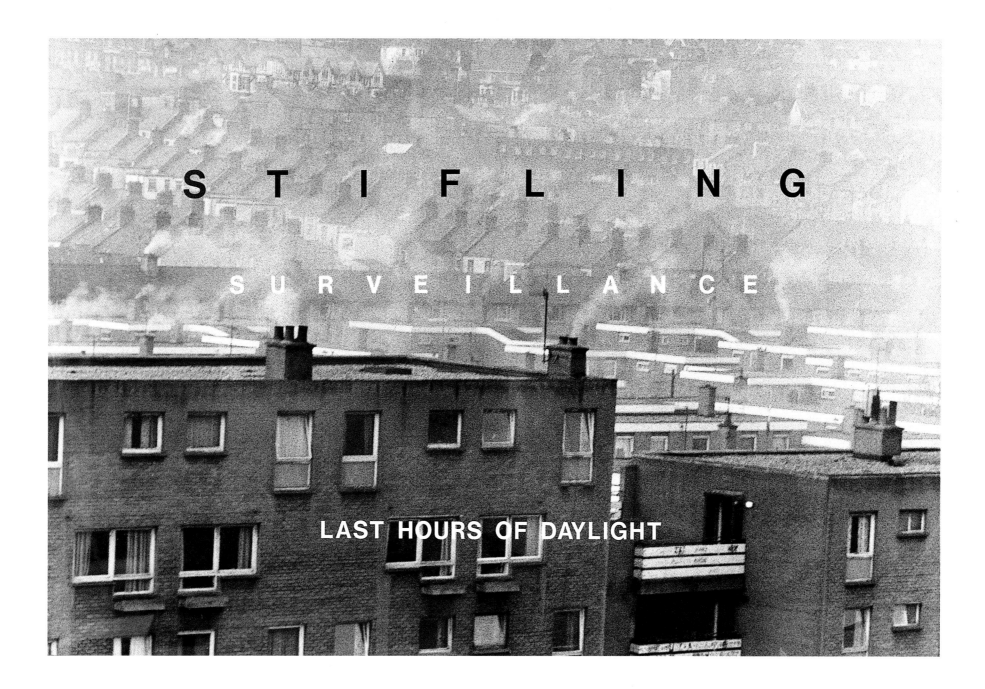

STIFLING

SURVEILLANCE

LAST HOURS OF DAYLIGHT

Black Spot 1997
Installation view, Angles Gallery, Santa Monica

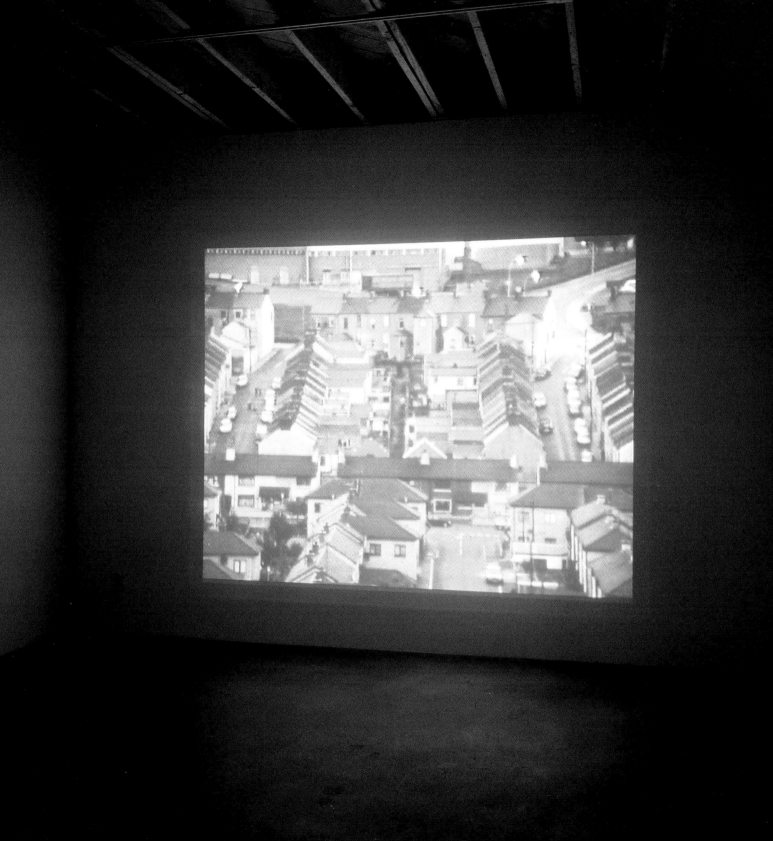

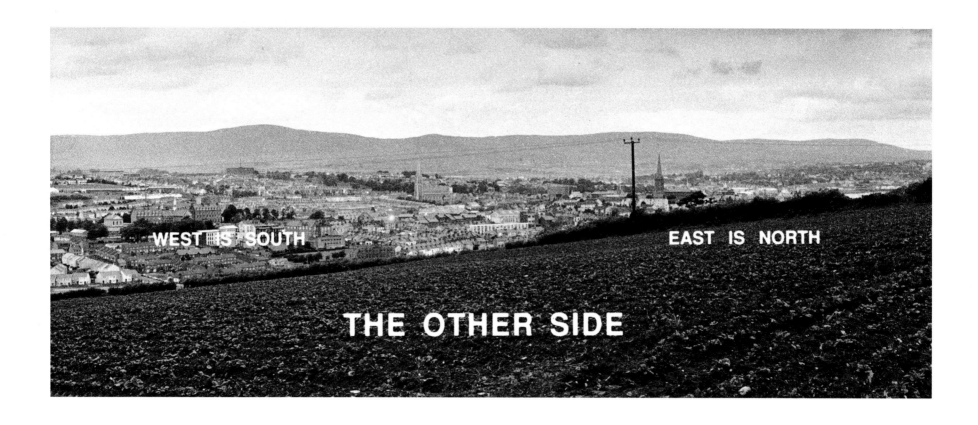

The Other Side 1988

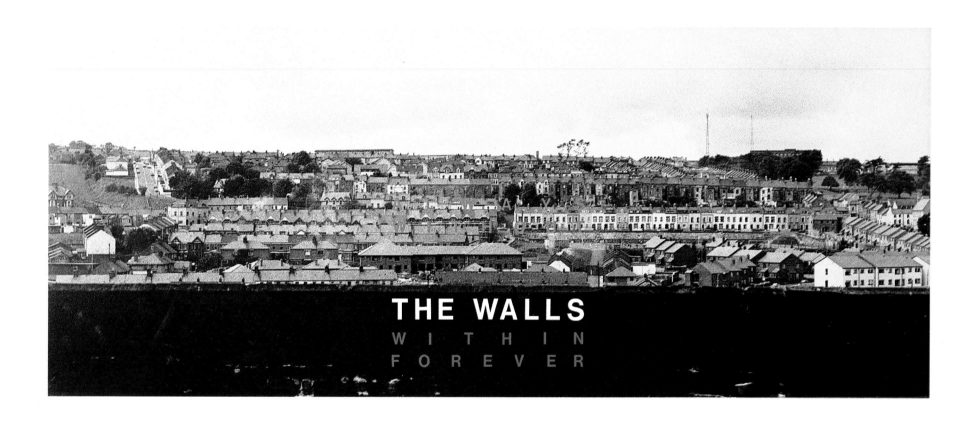

THE WALLS
WITHIN
FOREVER

The Walls 1987

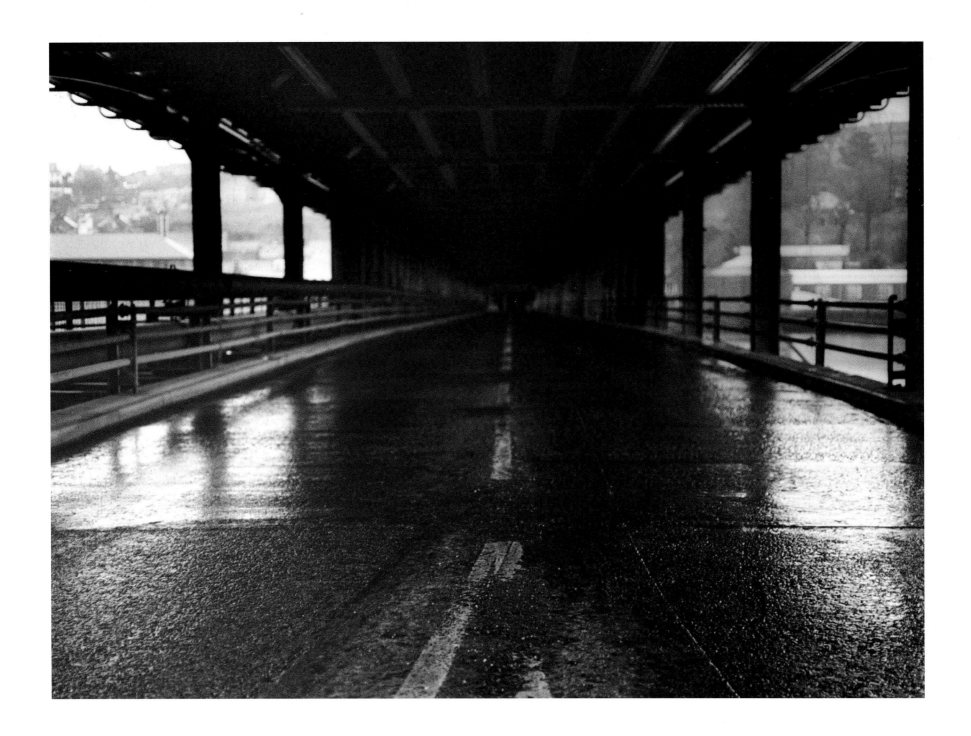

The Bridge 1992

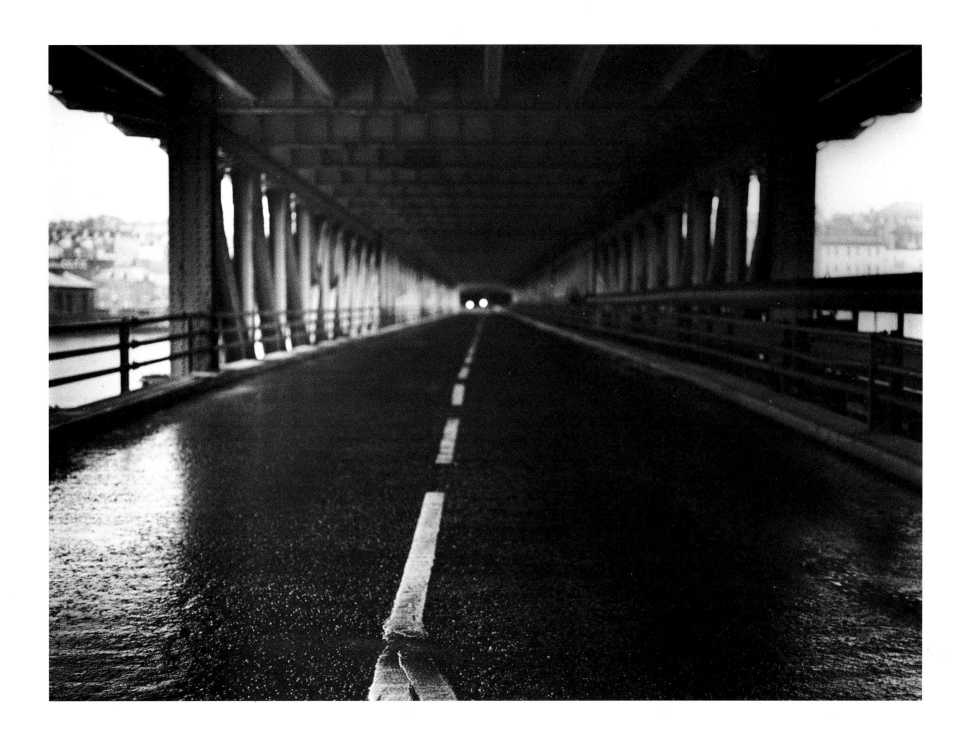

The clean sweet air is interrupted only by the lingering aroma of turf smoke.
I'm pathetic.
The verdant borders of twisting lanes are splattered with blood red fuschia.
I'm barbaric.
Nowhere is the grass so green or so lush.
I'm decent and truthful. It's in my bones.
Nowhere are the purples and blues of the mountains so delicately tinged.
I am ruthless and cruel.
Nowhere is the sea so clear and calm and, with barely a moment's notice,
the waves so dark and angry.
I am solid.
Nowhere has the sky such a range of delicate blues and mysterious greys.
I am essentially evil.
The sky is at its most dynamic in the West, where it is contrasted sharply
against the white limestone walls.
I never saw such walls.
They represent the blood and sweat of countless generations. For all this
land is 'made' land, hand made.
I am proud and dedicated.
For me, there is no alternative.
Upon seeing the grey barrenness of this limestone country one of
Cromwell's generals complained "there is not enough timber to hang
a man, enough water to drown him, or enough earth to bury him."
I am uncivilised and uneducated.
On a clear day, when there is no haze to obscure the view, it is possible
to gaze across the open landscape.
I have its history in my bones and on my tongue.
It's written all over my face.
Rain or shine, there are few landscapes whose colour, scale and contrast
impress so immediately.
I'm crazy.
Nowhere are the nights so dark.
So dark that you cannot see the end of the road.
I'm innocent.
I'm cynical.
Nowhere is the sand on the beaches so fine and white.
I am patient. I have a vision.
Smooth, age-worn stones wet with rain.
Even the rain is different there.
The soft Atlantic rain which often seems to cover the whole country adds
depth and subtlety to its colour.
I am dignified.

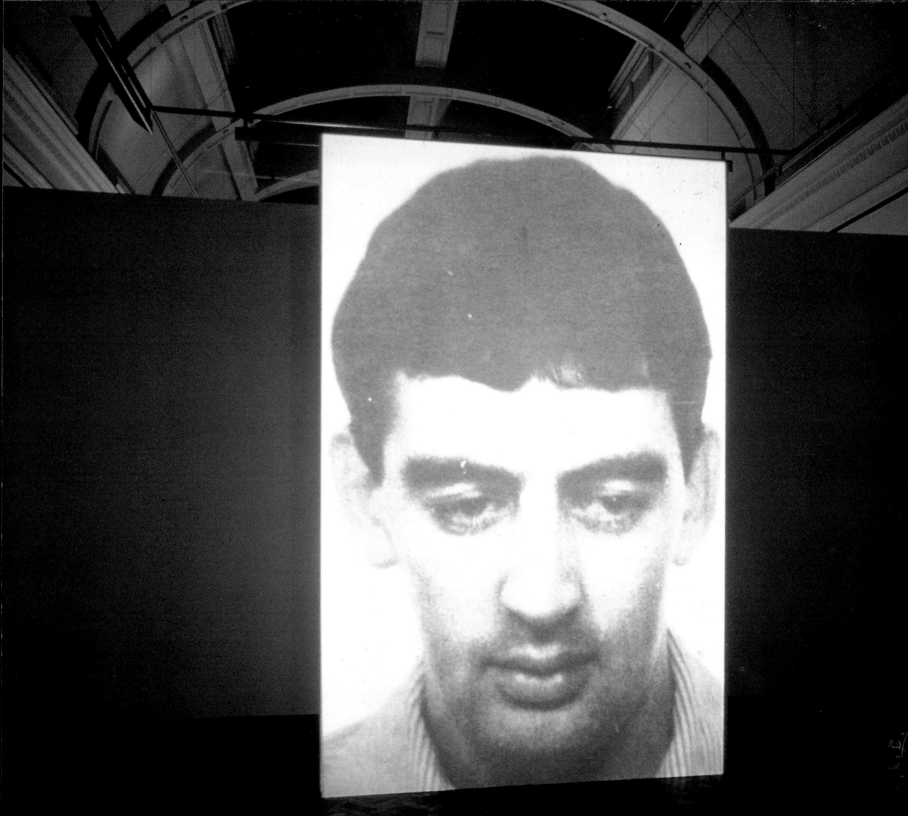

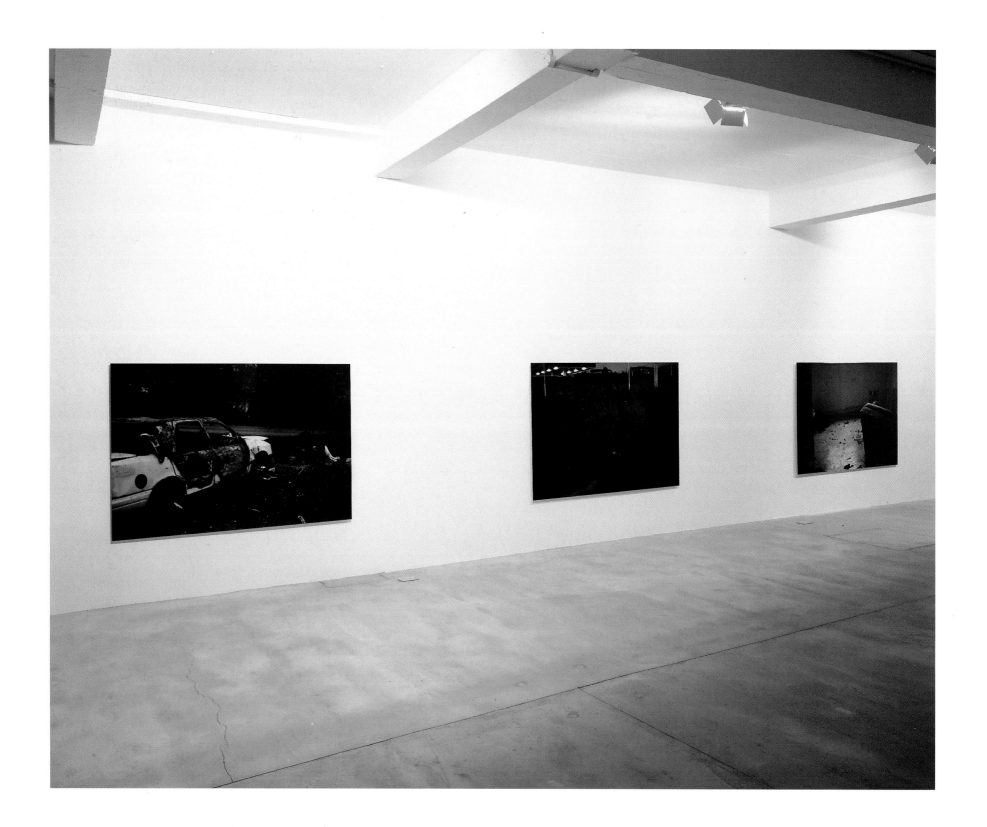

Installation view, **same old story**, Matt's Gallery 1997

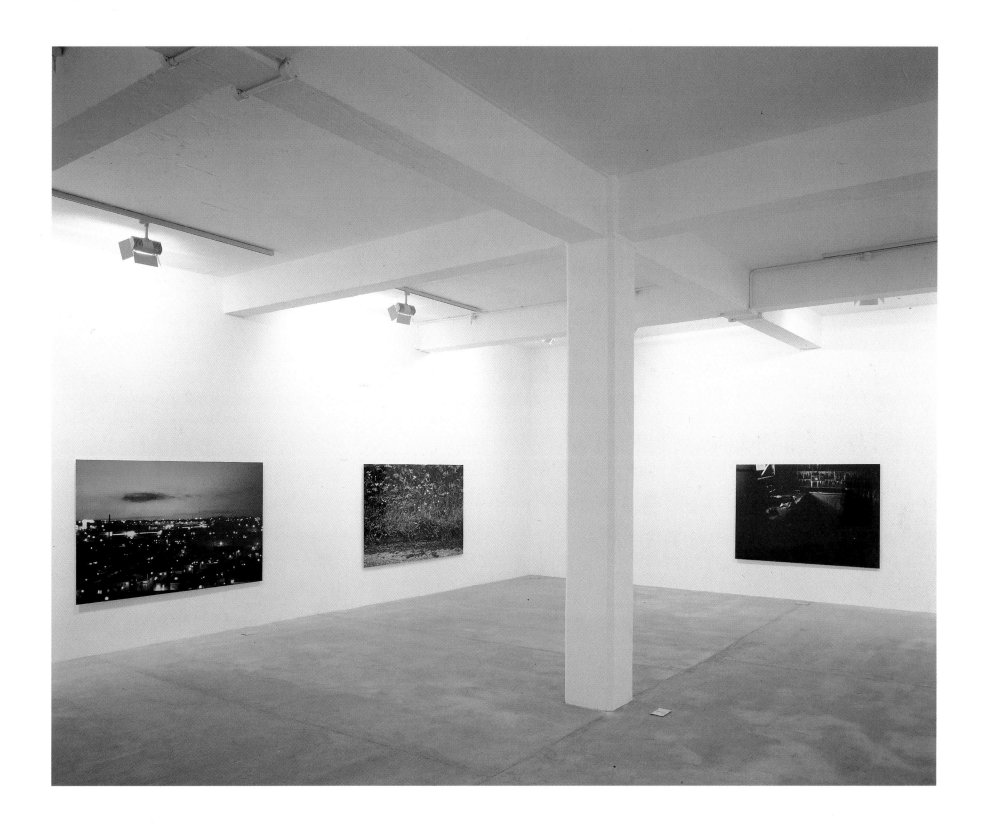

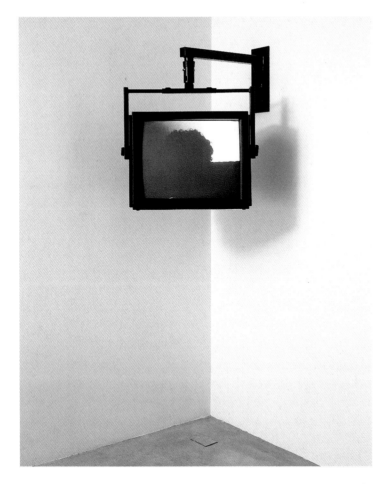

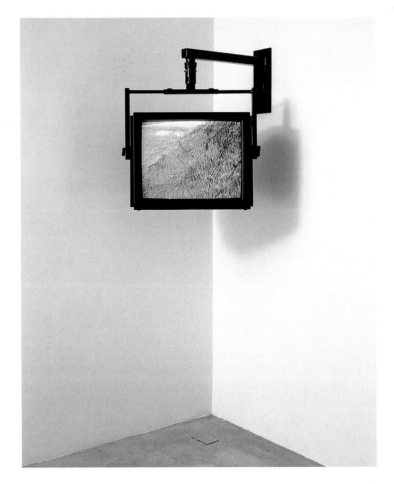

Man: … I never thought that it would happen to me. You know how it is… It's always someone else. Someone you don't know.

… She didn't look like the sort of woman who would be involved in that kind of thing, was very quiet, kept herself to herself. I couldn't believe it when I heard she was dead. It was like a dream.

… As soon as I saw him I knew he was one of them. He had a certain look on his face. After that he was a fucking dead man.

… I hate walking alone in the country. I feel exposed and vulnerable. I keep thinking someone is watching me or following me and I can't see them. I'm also frightened that I might find a body that has been hidden in the bushes.

… One night I had a dream I was taken prisoner. I was blindfolded and held in a small room. I lost all track of time, I don't know how long I was in there. Eventually three men came into the room. They tied me to a chair and asked me questions about my life. I thought they were going to kill me.

… I didn't know what was happening at the time. Like everyone else I read the newspaper reports and saw it on TV. As soon as I saw the body lying in the grass I knew it was her… I recognised the pattern of her jumper.

… I knew there was something going on even though no-one was talking about it. I could smell trouble… I could feel the tension. I wanted to find clues… I went looking for evidence. Look!… the photographs prove everything.

… I never thought that it would happen to me. You know how it is… It's always someone else. Someone you don't know…

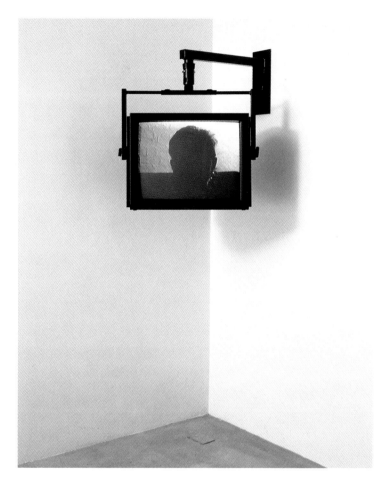

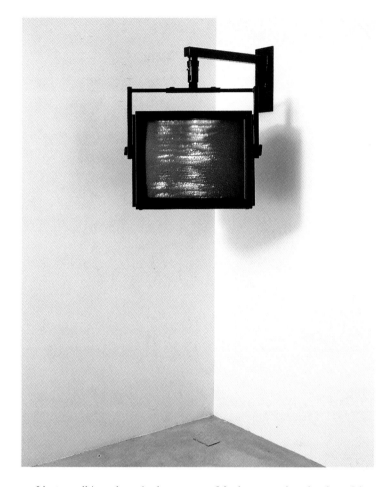

Woman: The first time I met him was in 1989, I thought he was OK but a little crazy sometimes. But I never thought he would do that.

...You hear all kinds of stories about people being watched and their house being bugged. I never really believed it, to tell you the truth... I wasn't even suspicious. I never heard any noise, never saw anything. I had no idea that there was someone listening to me... watching me.

...I never thought that it would happen to me. You know how it is... It's always someone else. Someone you don't know...

... Well, I was just walking down the street when I suddenly saw this guy being led away by a bunch of cops. I didn't recognise him at the time, but I found out later who he was.

... She didn't look like the sort of woman who would be involved in that kind of thing, was very quiet, kept herself to herself. I couldn't believe it when I heard she was dead. It was like a dream.

... I hate walking alone in the country. I feel exposed and vulnerable. I keep thinking someone is watching me or following me ... and I can't see them. I'm also frightened that I may come across a body that has been hidden in the bushes.

... Her body was found dumped on a track near the border by a woman out walking at 7am. Several hours earlier there had been reports of shots being heard in the area.

... The first time I met him was in 1989, I thought he was OK, but a little crazy sometimes. But I never thought he would do that.

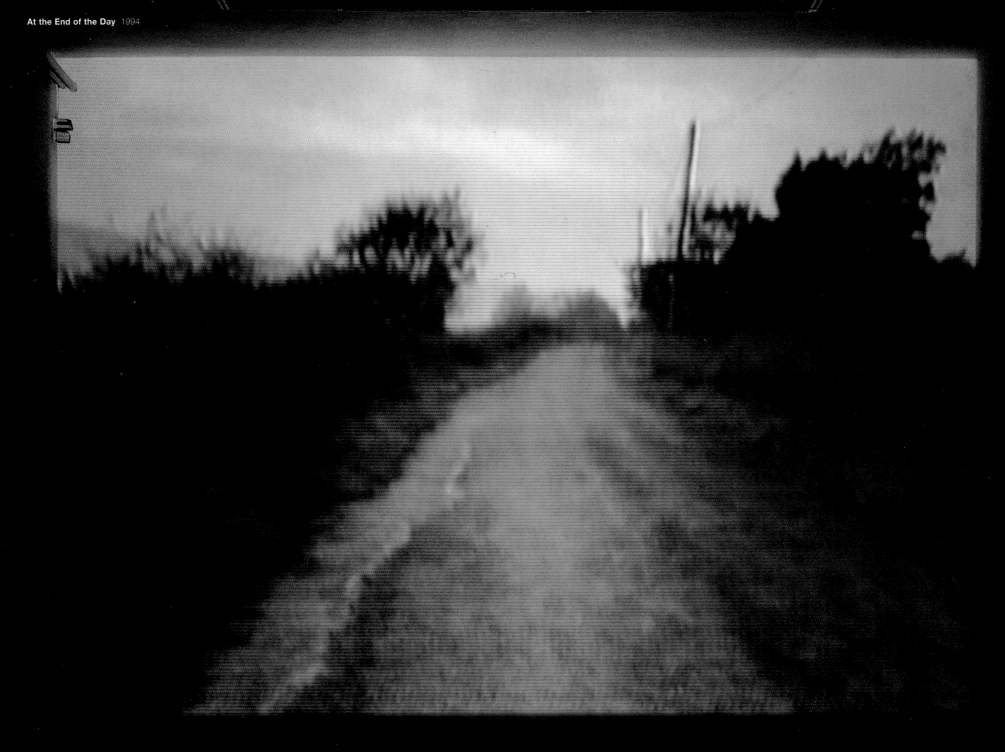

At the end of the day there's no going back.

We're all in this together.

We're entering a new phase.

Let's not lose sight of the road ahead.

Let's not repeat the mistakes of the past.

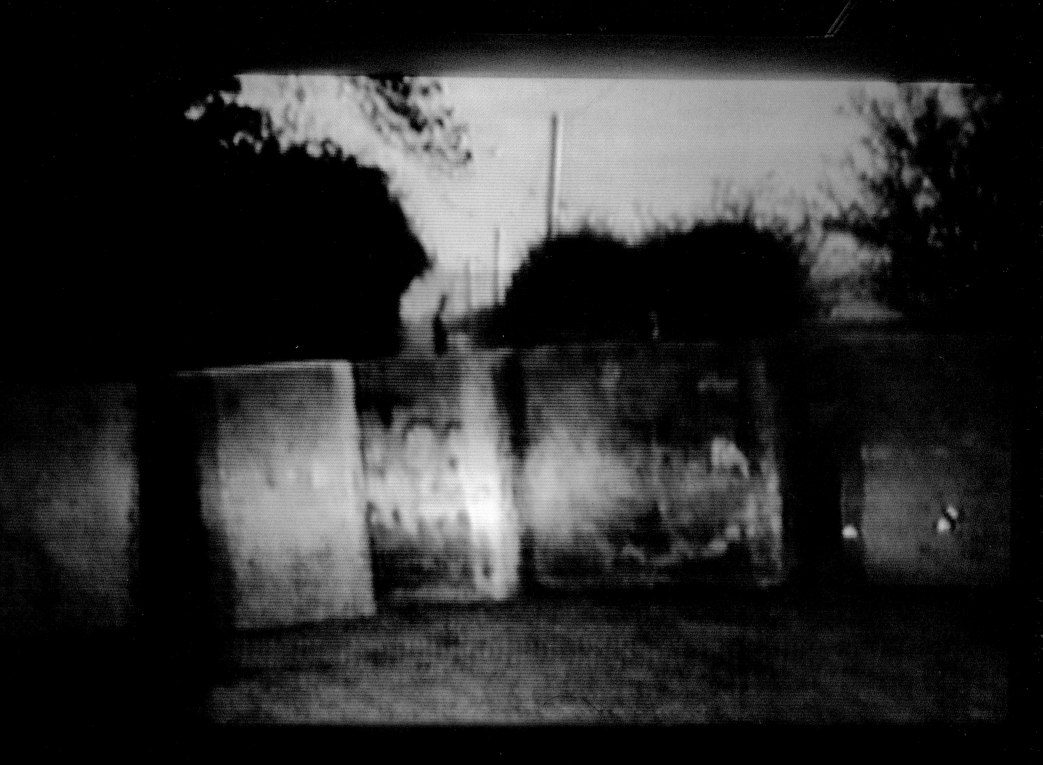

The only way is forward. We have to forget the past and look to the future.

Nothing can last forever.

There's no future in the past. At the end of the day it's a new beginning.

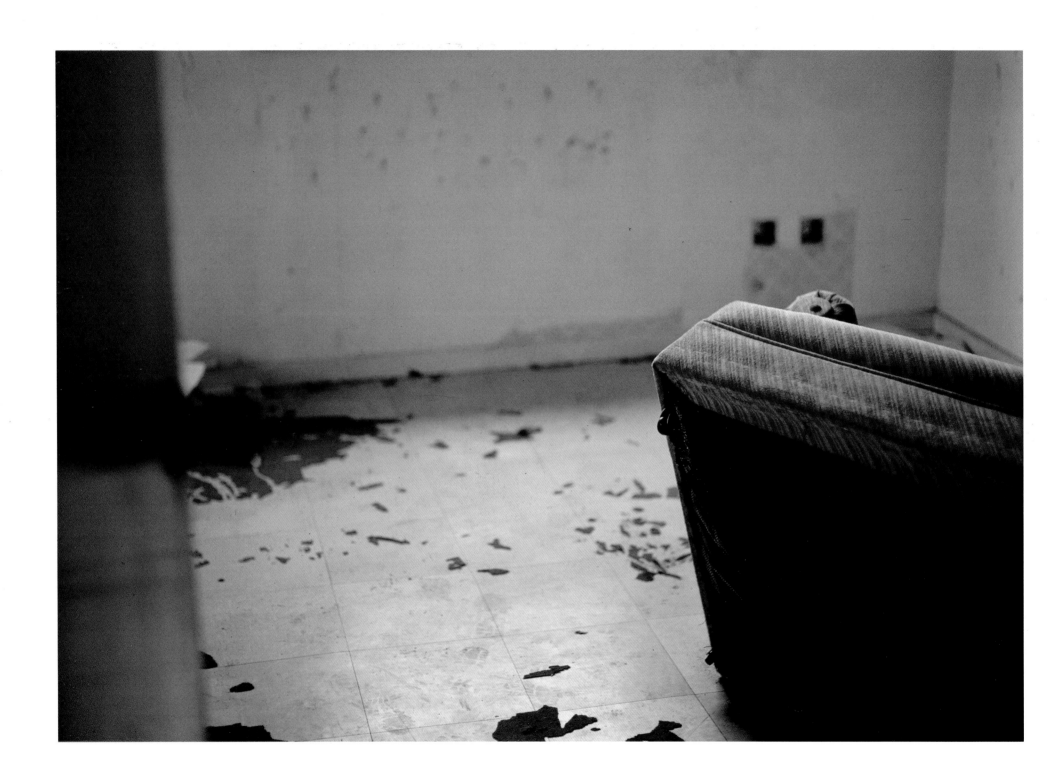

Abandoned Interior II 1997

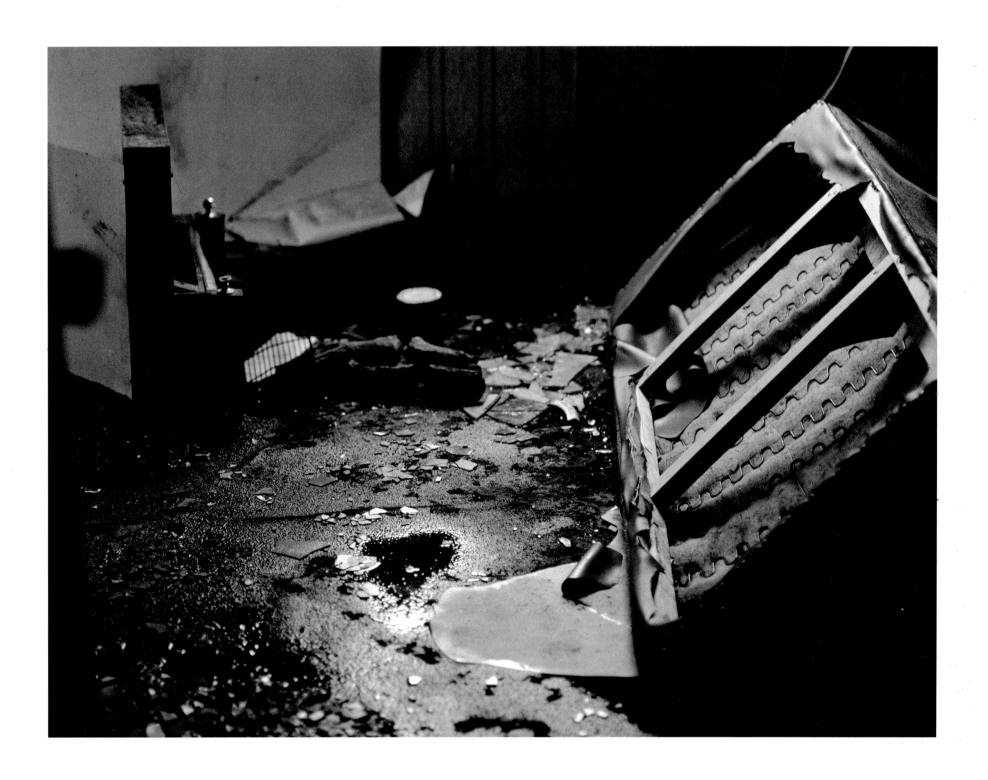

Abandoned Interior III 1997

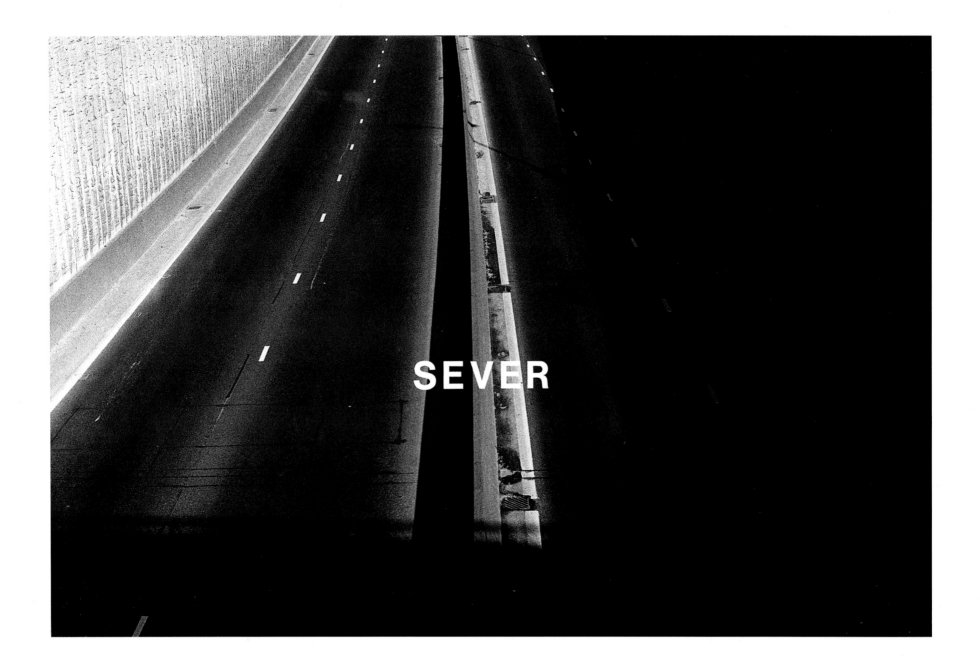

SEVER

Strategy: Sever/Isolate 1989

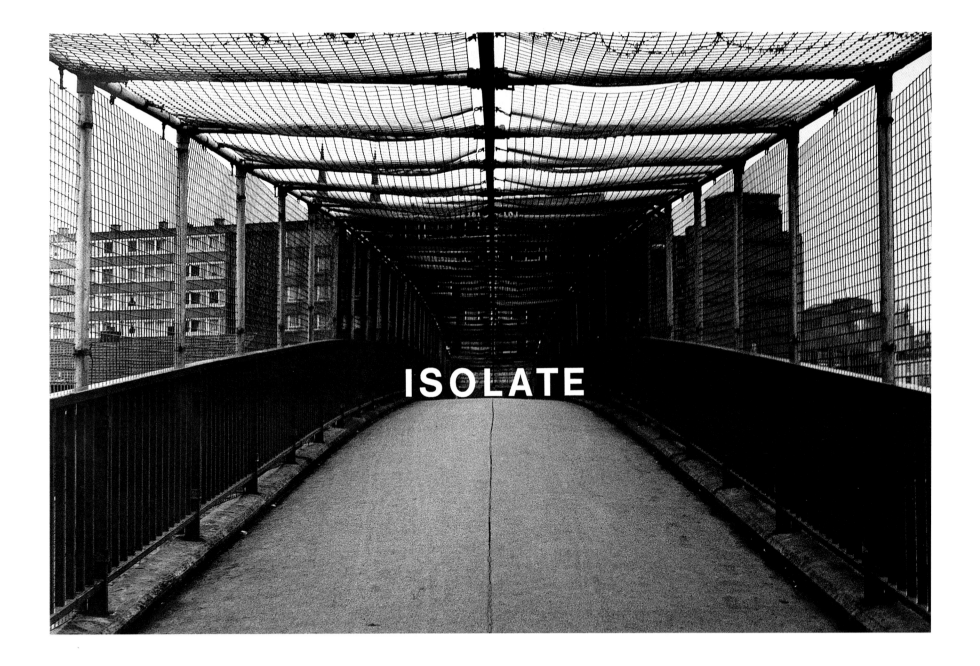

Next page
Left: **Uncovering Evidence that the War is Not Over I** 1995
Right: **Uncovering Evidence that the War is Not Over II** 1995

Disclosure I (Restricted Access) 1996

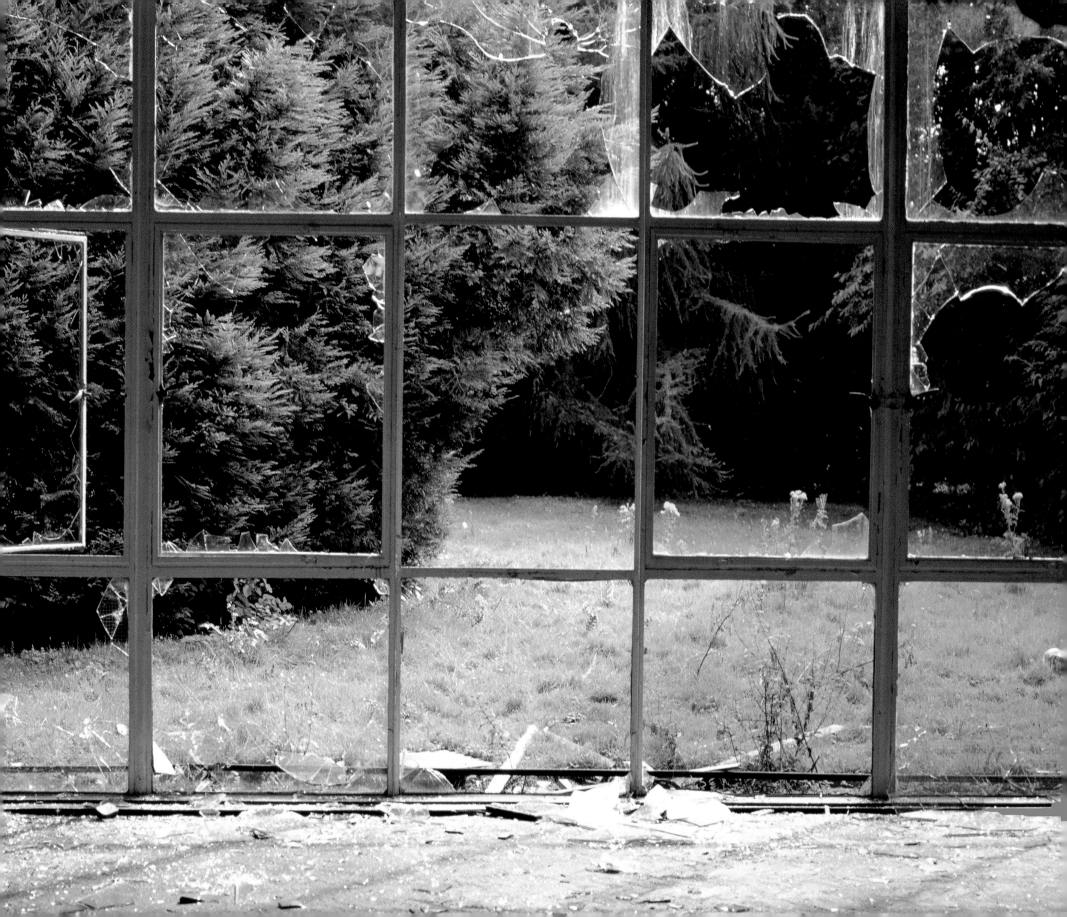

FAMILIAR AND UNKNOWABLE:
Works by Willie Doherty

'But she only learned that later.'
– Seamus Deane, Reading in the Dark

'Let's start at the beginning,' speaks the voice-over of Willie Doherty's most recent video work, *Somewhere Else*. We have already missed part of the beginning; the work is too physically complex to feel that one could ever follow it all, despite the speed at which it actually unfolds – which is measured, and mostly uses slow, synchronised fades between shots. That is not to mention the aural complexity, the co-presence of differing recorded sources: birdsong, the hum of an engine, footsteps. The man's voice has just been reading from a film script that blocks out precise camera movements which are to follow a man to a clearing in a forest, where he is to listen to the distant sound of a small river. Perhaps it is the same river we see projected, its water brown with peat and its surface spotted with foam. We don't see the man described, but start to become aware of our own act of peering and straining into the forest, as the camera moves through long zooms and slow, methodical shifts of focus.

The voice continues: 'For the purposes of clarity, let's say it's about a man in two places at the same time. A double life.' He sometimes sounds like an unconvinced actor rehearsing one half of a good cop/bad cop arrangement: 'Who said things were going to be simple?' Who indeed? Routinised claims of complexity like this often serve as obscurities placed over simple brutalities waiting further in the script. Before long we hear a brilliant, matter-of-fact statement of doubling and impossibility: 'The following scene takes place simultaneously somewhere else.' A voice-over in the movies is usually employed to give us the information we don't have and to smooth over the ellipses of hours, days, years as the narrative unfolds and the main character grows up, wises up or screws up. In the dark of a cinema we sit back and trust this voice that comes out of nowhere. Here, however, the voice-over arrives intermittently from different locations around the gallery. Our instinct is still to expect the narration to take charge of some of the uncertainties of what we are seeing and hearing, and – we hope – deliver a movement from beginning to end. Viewing habits which are dominated by experience outside galleries can't just be abandoned when we enter one, and the work doesn't, when all's said and done, mock our wish for resolution, for understanding. So we try to work out the point at which the piece begins and ends, and find that it is designed to generate the wish to re-view and re-listen, and we scrutinise every nuance and detail of the narrative particles, every aural blur.

It's also necessary to navigate the peculiar physical realisation of *Somewhere Else*: a solidly sculptural free-standing wooden L-shape or corner, which is staked out by the four projectors. We must cross their beams, casting shadows on the structure, in order to get to see the image-tracks playing on the other side. Like the man in the story, the viewer wanting to see the whole piece is put in the impossible position of needing to be 'in two places at the same time'. The experience of the work proves how hard it is in practice to translate these pulp clichés – or indeed negotiating table clichés – into fact, to be somewhere other than where you stand. It gives an obstinately physical demonstration that one's view is necessarily partial and occluded.

Doherty's works hold out techniques for thinking one position with another, one designation with another, in territories of feeling beyond the reach of fair employment legislation and the rhetoric of mutual respect for cultural traditions. Notably in *The Only Good One is a Dead One* (1993), he used a single actor's voice which moves between the roles of assassin and target, speaking over a repeated circuit of driving by night along a country road, and a fixed view from a parked car in a street. The theme is a familiar one in crime fiction, which often trades on the corrosive effects of an environment on any detective or innocent investigating it, and on how the stalked can become the stalker and vice versa. But there is no premature celebration of 'going over' to the other's point of view in Doherty's work, or any heroism involved in the passage. The suspension of identity and identification that his video works and photography can produce is traumatic, not inclusive. He operates at levels where to 'share' another's point of view is to participate in those feelings of everyday fear and anxiety where both sides are already substantially reduced to a set of routine twitches: dreams of getting out, replayed anticipations and dread of what's around the corner. That which is 'shared' is actually a parity of low expectations and fears. There is no claim that to use art to look speculatively at positions that are historical could eliminate them, or the complex of feelings by which they are sustained. They are evoked by Doherty's work with a quiet poetry, a poetry that is assembled from the simple elements of a contemporary visual vernacular which somehow he doesn't seem to be setting himself against or above. Northern Ireland has tended to sustain a more energetic literary culture than a visual one, and his intervention into the obviously accessible areas of the visual – surveillance techniques, flash photography, news, crime fiction and film, the Northern Ireland Office peace advertising campaigns[1] – has been welcome.

Somewhere Else continues Willie Doherty's prolonged engagement with Derry and its green hinterlands, urban emptiness, roads, anxieties and nightfalls; and also its population's tendency to travel and to dream in a westerly direction – to Inishowen, the peninsula that is topped by Ireland's most northerly point, Malin Head, but also part of 'the south' – and deeper into Donegal, to fantasies of getting out. 'He barely remembers how it all started anymore, but it has got seriously screwed up. Sometimes he closes his eyes and

imagines he's on a beautiful beach.' In *Somewhere Else* each shot dreams or falteringly remembers the next one, as we connect fragments of the monologue to what we see, and wonder which, if any, offer a stable place from which to understand the whole. In the old days, we imagine, everything was simple: we used to dream in soft-focus and pastel. These days we dream from a virtual library of flashbacks: in Steadicam and crane shots, in jarring hand-held, in the doubled/emptied time of automated surveillance and in zooms and focus pulls through lurid wet grass that go so close to what they are trying to understand that they lose it and fade to black – as though the blood-supply pumped to the brain had temporarily failed. It's as though a crimewatch programme has discovered abstract cinema. One of the four video projectors, all this time, shows a stroboscopic flicker of road markings vanishing under a car, as though the driver is struggling against sleep. One's retina is striped and made giddy. Road movies usually provide an idea of escape; here the road is no more than a lit pool of tarmac, the distant vista is not attainable.

That does not mean that the human wish for resolution can be bracketed out by the work, as Doherty knows. What sort of resolution does *Somewhere Else* reach? When the windows seen from afar, the rendezvous, the tip-off, and the dream of a forest and the foul-smelling pit of decaying farm animals are forgotten, one ends up on a beach. It is unlike that against which a family of four was silhouetted on the cover of the Good Friday Agreement, signed on 10 April 1998, which set out the terms for a power-sharing assembly. That beach turned out to be in South Africa (as an astute critic at the Belfast magazine *Source* worked out, there being no west-facing beaches in Northern Ireland[2]). In *Somewhere Else* the huge bulks of grey rock 'seem to be both an intrusion in the path of the sea and an echo of the shape of the water'. One is said to resemble the head of a shark, while others 'are both familiar and unknowable'. The characteristic restraint and understatement of Doherty's scripts here returns to the problem that has accompanied his portrayal of Derry and its environs all along: a dispute about the meanings of nature. In *Stone Upon Stone* (1986) black and white photographs of the west and the east banks of the River Foyle are arranged as a diptych: the work is designed for a corridor space so that the works face each other, and so that the viewer cannot see them both square on at the same time. (It's an effect quite unlike the 'mutual respect' arrangement of Nationalist and Loyalist painted kerbstones that line either side of the exit of the Tower Museum, which tells the story of Derry. Doherty is striving for something other than 'fairness'.)[3] The photographs are lettered with TIOCFIADH ÁR LÁ in green (Our Day Will Come, a Republican/Sinn Féin slogan) which accompanies THE WEST BANK OF THE RIVER FOYLE; and in blue THIS WE WILL MAINTAIN, a Loyalist slogan which accompanies THE EAST BANK OF THE RIVER FOYLE. The photographs have a strange and obstinately close focus on the inanimate, on rocks. In an early essay on the artist, Jean Fisher wrote '... If the phrase STONE UPON STONE alludes to the layered accumulation of cultural identity, what we are given to see in both images is its disintegration to 'nature' or chaos.'[4]

In the period since the work was made the queasily natural geographical boundary of the River Foyle has continued to be the marker that consolidates the Protestant population increasingly on the east bank, leaving fewer mixed areas on the west, the location of the walled city. The Fountain, a Protestant working class estate, just outside the walls, remains. The boundaries have continued to go up. In Belfast earlier this year the peace talks at Stormont were accompanied by the building of another peace wall between the two communities. It was the first to be built for some time, and is unlikely to be the last. People's decisions on where to live and where to shop are based on calculation and reasoning that is obvious, but also inaccessible in its implications: it is both familiar and unknowable, like those rocks. Doherty's constructive wishes as an artist have been to find forms of expression in situations where people can sense themselves only as victims, to give them tools for understanding. But it is to his credit that his work recognises, sometimes in ways his work cannot anticipate, people's failures to represent things to themselves. This gives that failure expression also, without freezing it in place.[5]

The constructive ambition in Doherty's work emerged early. In the mid 1980s he seized on the format of the topographic photograph overlaid or juxtaposed with words, as used in particular by Richard Long and Hamish Fulton, in order to insert the landscapes of contemporary Northern Ireland into a contemporary art language. The notion of using these techniques to deal with landscapes that were familiar and local rather than far away had a certain violence, but the primary aim was not parodic, wherever we may decide his disagreements with those artists' approaches to landscape may lie. The violence was more importantly a homeopathic counter-dose to the routine violences of journalistic and documentary representation, which have often served to construct an image of Northern Ireland as a series of 'incidents' disconnected from comprehensible political motivations.

What often emerged in the early photographic works was a radically indecipherable element. Photographs tend to divide into categories of pointing, identifying (of saying that this is an example of something, that it exemplifies a category) or – as more often when a proper photographer or an artist is involved – of staying with the moment of perception. In works such as the diptych *Fog Ice/Last Hours of Daylight* (1985), one image shows the Bogside, the Nationalist area outside and below the city walls, through a screen of weather, smoke and words. Footprints bruise the grass of a hoarfrost field, a tabula rasa of the natural, which vanishes into misted suggestions of the streets and buildings below. The wide-spaced letters SHROUDING PERVADING state again the obstruction to clear vision; the relationship between word and image in these works tends to be a troublesome doubling of what we see rather than a quick irony that allows us to move on. The companion image, a view through a long lens, coal smoke drifts over 'our territory of the sloping streets' (as Seamus Deane calls it in his brilliant autobiographical novel about an earlier Derry[6]); and over the more recently built dwellings in the foreground,

overlaid with the words STIFLING SURVELLIANCE. Stifling for precisely that population the view constructs for us as other.

It's a view of Derry – the security forces' view – that Doherty has continued to test. We find it again in the more recent colour photographs, which are no longer overlaid with words. *Critical Distance* (1997), photographed after sunset, shows the view from the lookout point on the city as a constellation of streetlamps and lights from windows. *Black Spot* (1997) is a real-time video surveillance work made from the same point on the walls as night falls. It is an appallingly fascinating work which allows one to follow the movements of cars and people, including children playing in the street.

The obscurities so often figured are not simply frustrations to the view of the RUC and the army, however; they are obscurities and twilights within Republican sentiment also, which have all along been held up for troubled scrutiny by Doherty's work. In an interview in 1993, Doherty remarked that 'In the business of trying to visualise the conflict, Sinn Féin and the Northern Ireland Office often end up using the same vocabulary of images'.[7] *They're all the Same* (1991), a projection/audio work included in this exhibition, is one such work that sought to find constructive room for manoeuvre in the period of the broadcasting bans on political organisations with paramilitary connections. The Media Broadcast Ban, passed by the British Parliament in 1988 at a time of increased political activity by Sinn Féin on both sides of the border, placed restrictions on the broadcasting of the words and voices and found new employment for actors who read out their words. It was preceded by a ban in the Republic of Ireland. In this period of chronic political inertia at Westminster, faltering covert dialogue proceeded and so did the public denials from on high of ever sitting down to talk with terrorists. For all the absurdity of the ban, which ended with the first IRA cease-fire in 1994, censorship was in some ways internalised during this period. In that the space for hearing what those criminalised as terrorists had to say about the situation or how it might change was squeezed out, they had either to be terrorists or heroes incapable of the cruelties they so often inflicted on their own people. Television viewers in Northern Ireland got the message: that they were adjudged incapable of understanding when such people had a point and when they were rehearsing hate-speech and old dogma.

They're all the Same consists of a slide projection of a newspaper photograph of the face of Nessan Quinlivan; it had become particularly well known since his escape from Brixton Prison, South London, where he was awaiting trial on terrorist charges[8]. The texts spoken over this photograph – which away from a newspaper front page looks contemplative, even quietly assured – offer a series of contradictory self-characterisations: 'I'm crazy. I'm innocent. I am solid. I am proud and dedicated. It's written all over my face.' Motivation appears through the tie to the country, to land: it is naturalised and romanticised: 'Nowhere are the purples and blues of the mountains so delicately tinged.

Smooth, age-worn stones, wet with rain. Even the rain is different there. The soft Atlantic rain which seems to cover the whole country adds depth and subtlety to its colour.' But in some statements Republican sentiment, albeit faltering, is voiced: 'I never saw such walls. They represent the blood and sweat of countless generations. For all this land is 'made' land, hand made.'

It is easy now to agree with Doherty's words from the same interview that 'If we fail to understand the political motivation of organisations like the IRA and the UVF then we become completely victimised because we have no means of negotiating with these people'. It is only through this kind of thinking that any political progress has been made. The general perception in Britain through the 1990s has nevertheless often been that the IRA's bombing campaign was incomprehensible and detached from the government's failure to keep talks towards a political settlement going. In the film *London*, by Patrick Keiller, which recounts walks around the city in 1992, the detached mood is captured: 'The bomb had gone off at 7.10 that morning. We'd heard the bang, but had not known what it was. [...] It was two days after the nineteenth anniversary of the bombs at the Old Bailey in 1973, the first IRA attack on London. Again, having been away for such a long time, I found it strange how quickly these events are forgotten by the general public. When I asked him, Robinson could remember the mortar attack on Downing Street in February the year before, but not the eight or so devices since. He seemed to have become conditioned to the idea that what was happening in Ireland did not have much to do with him.'[9]

It will be interesting, when the histories of soap opera, TV and film of the 1990s are written, to quantify the attempts made to explain the links of events 'somewhere else' with those on everyday life across the water. The contribution a visual artist can make to such a situation is in many ways limited; but as increasing opportunities came to show internationally Doherty continued to make works with a constructive political approach – exemplified by *They're all the Same* or *30 January 1972* (1993) a work on the processes by which the event known as Bloody Sunday is remembered in Derry by people either present or not present on that day – complemented by wordless video pieces and continued use of still photography, now exclusively in colour. Finding ways to work and communicate in this international context has brought out the connections of Doherty's work with much broader questions of powerlessness and the contemporary dominance of crime narrative as a way of visualising place. His decision not to take up invitations to make works in direct response to other locations but to continue to work from the one he is in looks increasingly like the right one, and one which has allowed deeper reverbera-tions to emerge. *The Only Good One is a Dead One* (1993), the evocative wordless video work *same old story* (1997), and the new work, *Somewhere Else* (1998) make a distinct group, and show an increasing technical sophistication in the way they make self-conscious the mechanisms by which we project narrative and attempt to identify what we see.

These concerns also emerge in the still photographs, but in a different time-scale that permits us to step back, and to examine close up, to look at our own pace. They are large in scale and are usually placed on the wall at a surprisingly low height so that one feels lost in them rather than being able to master or contain them. Many employ a central area of blackness and exploit areas of unfocus and unknowability – impressively in *Tunnel* (1995) and *The Fence* (1996), where the brightness of the flash on the chain-link serves only to emphasise how small the distance is that it can illuminate. But while the use of flash and some of the conventions of crime-scene documentation and reconstruction are noticeable, the mood is not uniform. In series such as *At the Border* we are faced with works that pull a perplexing aesthetic appeal from their subject, and the possibility of a vista, of seeing beauty for what it is even at this location. The deep focus of the shaded road shown in *At the Border I (Walking towards a military checkpoint)* (1995) offers spatial experience and uncertainties of a kind impossible in the texture of video. *At the Border III (Trying to forget the past)* (1995) turns away from the vanishing point of the road to reveal the true colours of the landscape of the Foyle valley running alongside it. *Abandoned Interior II* (1997) is one of a series taken in a vacated home in The Fountain (which also features in *same old story*). This image of a pool of water on an uneven, crumbling floor reflecting light from an unseen window has a solemnity that is hard to fathom. Perhaps in part this is because the only other familiar location in which a high source of natural light would reflect in this way is in an unlit church. But the movement between document and generality, is always a profoundly troubled one. This and other photographs succeed in making a series of near iconic depictions (the road, the roadblock, the burnt-out car; the abandoned home) but they don't encourage us to play the game of seeing resemblances or straying from the evidence. If they have a plot it is of a continued investigation into an event that has happened or been frequently imagined and which cannot any longer be localised. They have been described as 'giving us excessive detail in areas in which we are uninterested and too little where we are' and of generating a kind of attention, a demand for a meaning, a semantic content to perception, that ultimately 'stands between us and what we have come to see.'[10]

To have forms of knowledge not backed up with experience of this somewhere else – for which the photographs provide a strange proxy form, an 'I was there, I saw this' – is to have only partial knowledge. And yet simply to perceive or be always perceiving, to always have to pay close attention to every detail and evidence of language and expression, of terrain and movement, to the exclusion of everything else, has created its own kind of perceptual deadlock. It is like a kind of constant fantasying denuded of a properly sustaining fantasy. For Seamus Deane, whose book *Reading in the Dark* seeks to piece together the political violence in Derry through the earlier part of the century and the destructive silences in his family that grew up around it, the ghost story retained some possibility. His book is studded with ghost stories and mysteries of fantastic power which people employ to rumour, hint at and displace their worst imaginings, to give meaning to the imposition

of the border and the betrayals that cannot be confessed. Willie Doherty's works, in the latter part of the conflict, have risked much in their prolonged engagement with the replayed shards of feeling arising from a particular place, but the formal means which he has found to convey the everyday estrangement and underlying numbness are of wide relevance. People almost everywhere find themselves fascinated by detective narratives, fictions relentlessly built around a rhetoric of fact, investigation and evidence; but if asked cannot always say what in them it is that they seek, or locate the frustration that results when they end too neatly.

Ian Hunt

1
Two witty essays by Martin McLoone on the NIO advertisements, which were not seen elsewhere in the UK, are included in *Willie Doherty: same old story*, Matt's Gallery, London; Orchard Gallery, Derry; Berwick Gymnasium Gallery, Berwick-upon-Tweed; firstsite, Colchester; Le Magasin, Grenoble, 1997–1998

2
Mullin, John, *How Cape Sun Set On Ulster's Future*, The Guardian, 15 June 1998

3
The city council did not want any mention of 'the Troubles' in the original plan for the Tower Museum, founded 1992, but was eventually prevailed upon to provide an even-handed account

4
Fisher, Jean, 'Seeing Beyond The Pale', in *Unknown Depths*, Ffotogallery, Cardiff; Third Eye Centre, Glasgow; Orchard Gallery, Derry; Institute of Contemporary Arts, London; John Hansard Gallery, Southampton; Angel Row Gallery, Nottingham, 1990

5
See Jaki Irvine's subtle account *The Only Good One is a Dead One*, Third Text, No. 26, Spring 1994, pp. 102–106

6
Deane, Seamus, *Reading in the Dark*, Vintage, London, 1997

7
Willie Doherty interviewed by Iwona Blazwick, *Willie Doherty*, Art Monthly, No. 172, December/January, p. 4

8
Brixton Prison, off most tourist routes, is where Terence MacSwiney, Republican Mayor of Cork and hunger-striker, died in 1920

9
Keiller, Patrick, *London*, Koninck/BFI, 1993

10
Cubitt, Sean, *Willie Doherty*, Art Monthly 208, July/August 1997, p. 42

Fade up to a scene in a forest. A man walks along a cool
shaded path. He moves cautiously. He has parked his car
some distance away as he doesn't want to attract any undue
attention. The camera follows him from behind. He comes to
a small clearing in the trees and stops to listen to the distant
sound of a small river. As he looks around we see him from
above. A high crane shot gives us this unnatural vantage
point. We see him and he doesn't even know we're watching
him.

Let's start at the beginning.
It's a straight forward story, with a twist.

For the purposes of clarity, let's say it's about a man in two
places at the same time. A double life.

Who said things were going to be simple? Things are never
what they seem. There's always something waiting just around
the corner.

Meanwhile, he arrives for the meeting. Fade up to a wide shot
of a disused industrial landscape. He stops the car beside a
line of old storage units. As he waits his concentration slips
and he remembers a dream he had the previous night. He is
in a forest. It is the middle of the night. He's walking towards
a distant light, barely visible between the trees. As he
approaches he can hear a scraping noise. Eventually he is
close enough to observe two men digging a hole. Then they
drag his body from a car and throw it into the hole.

The following scene happens simultaneously somewhere
else.

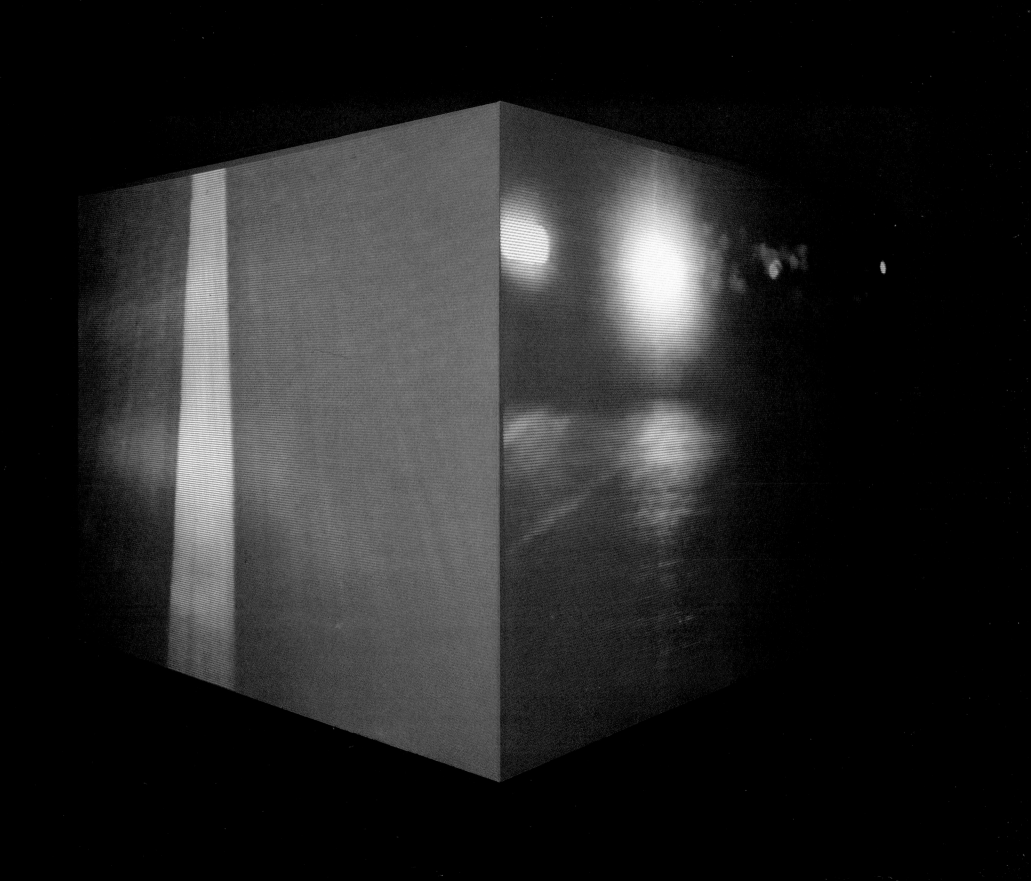

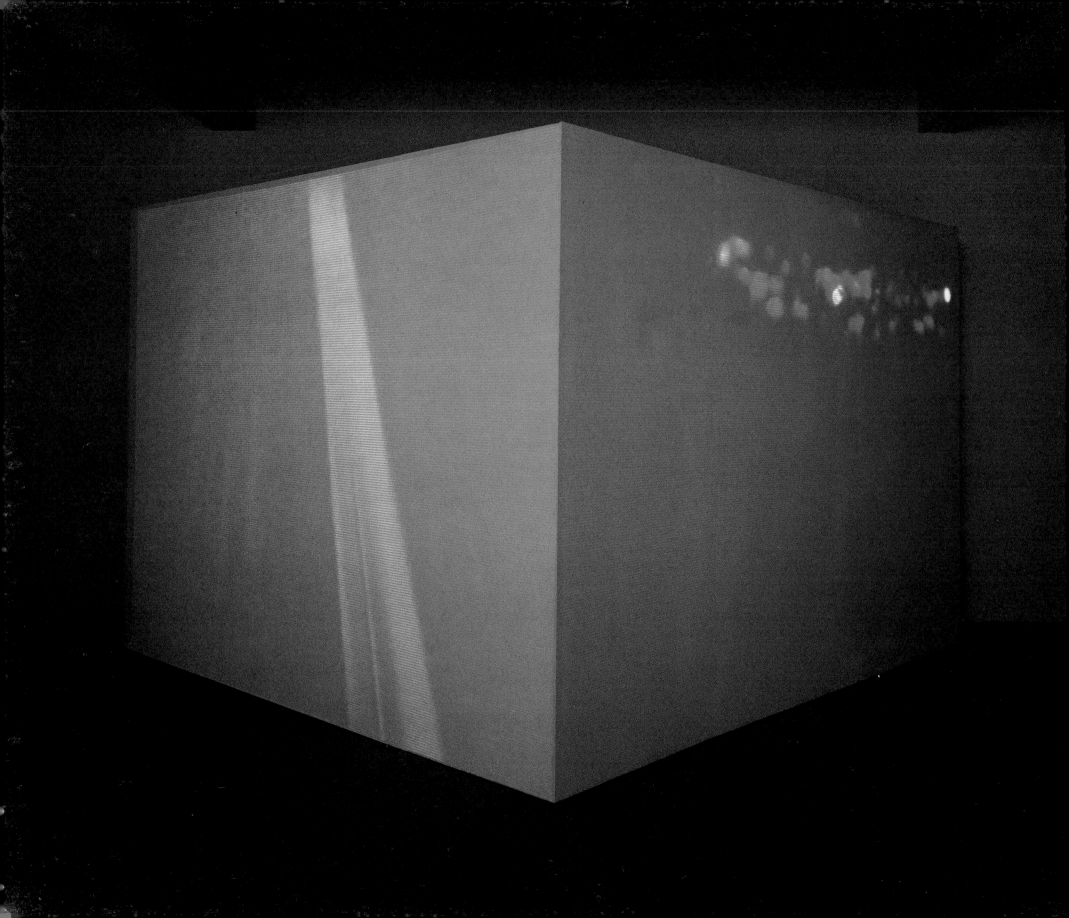

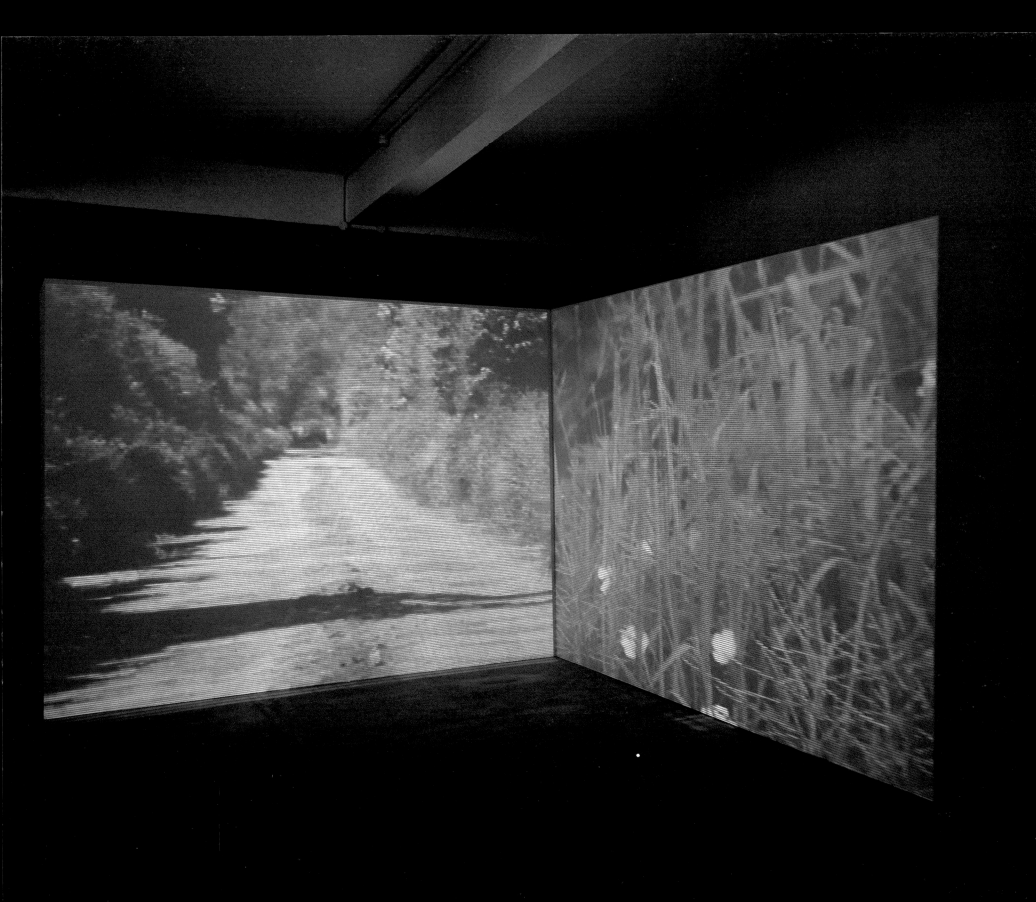

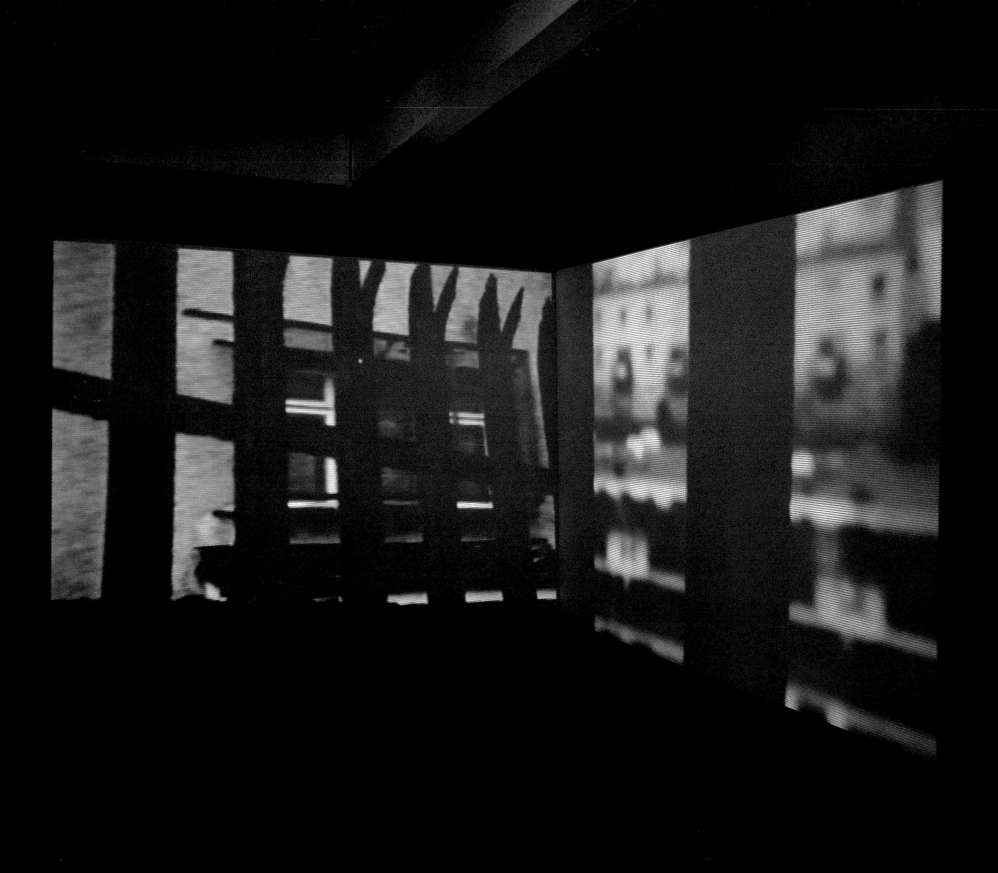

A nondescript stretch of country road.
The camera looks straight up the road focused on a point
somewhere in the distance. After a few minutes a car
appears around a bend in the road. It continues to drive
along the road steadily getting closer and closer to the
camera. Unexpectedly, the car stops and an unknown man
gets out of the car and drops an unidentified object into the
hedgerow at the side of the road. He gets back into the car
and drives off.

He's starting to lose it.
He struggles to keep a hold on things. A grip on reality.

His body was discovered in a foul smelling pit full of the
decomposing remains of dead farm animals. He had been
beaten so badly that police were only able to identify him
from one fingerprint and his dental records.

Meanwhile, a helicopter hovers above the countryside, close
to the border. Inside a video screen flickers with the infrared
image of a ditch.

Interior. Badly furnished flat. Night.
The only light comes from the glow of a television in the
corner.
He is alone, lying on a sofa, intently watching a news
programme.
He has fantasies about getting out. He barely remembers
how it all started anymore, but it has got seriously screwed
up. Sometimes he closes his eyes and imagines he's on a
beautiful beach. Somewhere on the west coast when things
were a lot simpler.

by years of exposure to the incessant patterns of the tides. One looks like the head of a shark, another snakes along the sand. Others are both familiar and unknowable.

There's been a tip-off. Everything is in place. Nothing can ever be the same again. It's over apart from some last minute details.

Exterior. A high vantage point overlooking the city. Dusk. The camera is fixed on this scene with a wide angle. After five or ten minutes small dots of light begin to appear as the street lights below are switched on. Very slowly, almost imperceptibly, the camera begins to zoom in on the distant city. Gradually the frame is filled only with buildings. The long slow zoom continues relentlessly until a single window is framed neatly in the viewfinder.

He saw him recently on television. He couldn't believe it was him. He looked for some visible sign of remorse or regret. Nothing.

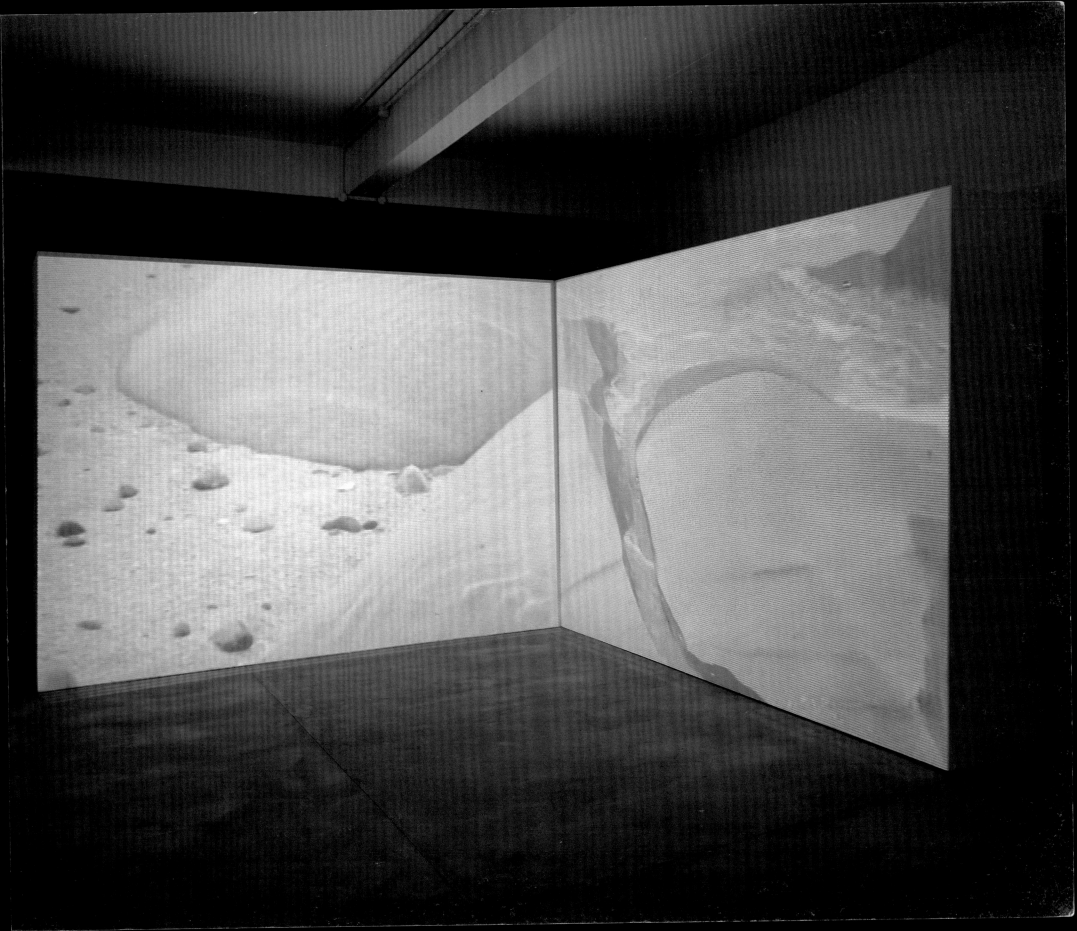

Willie Doherty was born in Derry in Northern Ireland in 1959.
He currently lives and works in Derry.

One Person Exhibitions

1986 *Photoworks*, Oliver Dowling Gallery, Dublin
 Stone Upon Stone, Redemption!, Derry

1987 *The Town of Derry, Photoworks*, Art and Research Exchange, Belfast

1988 *Colourworks*, Oliver Dowling Gallery, Dublin
 Two Photoworks, Third Eye Centre, Glasgow

1990 *Imagined Truths*, Oliver Dowling Gallery, Dublin
 Same Difference, Matt's Gallery, London

1990–91 *Unknown Depths*, Ffotogallery, Cardiff; Third Eye Centre, Glasgow;
 Orchard Gallery, Derry; Institute of Contemporary Arts, London;
 John Hansard Gallery, Southampton; Angel Row Gallery, Nottingham*

1991 Tom Cugliani Gallery, New York
 Kunst Europa, Six Irishmen, Kunstverein Schwetzingen

1992 Oliver Dowling Gallery, Dublin
 Peter Kilchmann Gallery, Zürich
 Tom Cugliani Gallery, New York

1993 Galerie Jennifer Flay, Paris
 30 January 1972, Douglas Hyde Gallery, Dublin
 They're all the Same, Centre for Contemporary Art, Ujazdowski Castle,
 Warsaw

1993–94 *The Only Good One is a Dead One*, Matt's Gallery, London; Arnolfini,
 Bristol; Grey Art Gallery, New York*

1994 *At The End Of The Day*, The British School, Rome*

1995 Galerie Jennifer Flay, Paris
 Kerlin Gallery, Dublin
 Peter Kilchmann Gallery, Zürich

1996 Alexander and Bonin, New York
 Galleria Emi Fontana, Milan
 Musée d'Art Moderne de la Ville de Paris, Paris*
 In the Dark. Projected Works by Willie Doherty, Kunsthalle Bern, Bern*
 The Only Good One is a Dead One, Fundação Calouste Gulbenkian,
 Lisbon*
 The Only Good One is a Dead One, Edmonton Art Gallery, Edmonton;
 Mendel Art Gallery, Saskatoon; Art Gallery of Windsor, Windsor;
 Art Gallery of Ontario, Toronto*

1997 Peter Kilchmann Gallery, Zürich
 Kerlin Gallery, Dublin

1997–98 *Willie Doherty: same old story*, Matt's Gallery, London; Orchard Gallery,
 Derry; Berwick Gymnasium Gallery, Berwick-upon-Tweed; firstsite,
 Colchester; Le Magasin, Grenoble*

1998 Angles Gallery, Santa Monica

Group Exhibitions

1987 *A Line of Country*, Cornerhouse, Manchester
Critic's Choice, City Art Gallery, Limerick
Directions Out, Douglas Hyde Gallery, Dublin*
The State of the Nation, Herbert Art Gallery, Coventry

1988 *Gallery Artists*, Oliver Dowling Gallery, Dublin
Three Artists, Battersea Arts Centre, London

1988–89 *Matter of Facts*, Musée des Beaux Arts, Nantes; Musée d'Art Moderne, Saint-Etienne; Metz pour la Photographie, Metz*

1989 *I Internationale Foto-Triennale*, Esslingen*
Three Artists, London Street, Derry
Through The Looking Glass, Barbican Art Gallery, London*

1990 *A New Tradition*, Douglas Hyde Gallery, Dublin*
The British Art Show, McLellan Galleries, Glasgow; Leeds City Art Gallery, Leeds; Hayward Gallery, London*
XI Photography Symposium Exhibition, Graz

1991 *A Place For Art?*, The Showroom, London
Denonciation, Usine Fromage, Darnetal, Normandy
Europe Unknown, WKS Wawel, Ministry of Culture, Krakow*
Inheritance and Transformation, The Irish Museum of Modern Art, Dublin*
Outer Space, Laing Art Gallery, Newcastle-upon-Tyne; Ferens Art Gallery, Hull; Camden Arts Centre, London; Arnolfini, Bristol*
Political Landscapes, Perspektief, Rotterdam
Shocks to the System, Royal Festival Hall, London; Ikon Gallery, Birmingham*
Storie, Galleria il Campo, Rome; Galleria Casoli, Milan*

1992 *Denonciation*, Centre d'Art Santa Monica, Barcelona*
Moltiplici Culture, Convento di S.Egidio, Rome*
Outta Here, Transmission Gallery, Glasgow
Shocks to the System, Chapter, Cardiff
13 Critics 26 Photographers, Centre d'Art Santa Monica, Barcelona*
Time Bandits, Galleria Fac-Simile, Milan

1993 *An Irish Presence*, Venice Biennale, Venice*
Critical Landscapes, Tokyo Metropolitan Museum of Photography, Tokyo*
Krieg (War), Neue Galerie, Graz*
Prospect 93, Frankfurter Kunstverein, Frankfurt*

1994 *Cocido Y Crudo*, Museo Nacional Centro de Arte Reina Sofia, Madrid*
From Beyond the Pale: Selected Works and Projects, Part 1, Irish Museum of Modern Art, Dublin*
Kraji/Places, The Museum of Modern Art, Ljubljana, Slovenia*
Points of Interest, Points of Departure, John Berggruen Gallery, San Francisco
The Act of Seeing (Urban Space), Fondation pour l'Architecture, Brussels*
The Spine, Foundation De Appel, Amsterdam*
Turner Prize 1994, Tate Gallery, London*
Willie Doherty, Mona Hatoum, Doris Salcedo, Brooke Alexander Gallery, New York

1995 *Distant Relations*, Ikon Gallery, Birmingham*
IMMA/Glen Dimplex Award Exhibition, The Irish Museum of Modern Art, Dublin*
It's Not A Picture, Galleria Emi Fontana, Milan
Make Believe, Royal College of Art, London*
New Art in Britain, Muzeum Sztuki, Lodz*
Photoworks from the Collection, The Irish Museum of Modern Art, Dublin

Sites Of Being, Institute of Contemporary Art, Boston
Trust, Tramway, Glasgow
Willie Doherty, Andreas Gursky, Moderna Museet, Stockholm

1996 *ACE! Arts Council Collection New Purchases*, Hatton Gallery,
Newcastle-upon-Tyne; Oldham Art Gallery, Oldham; Hayward Gallery,
London
Being & Time: The Emergence of Video Projection, Albright-Knox Art
Gallery, Buffalo*
Circumstantial Evidence: Terry Atkinson, Willie Doherty, John Goto,
University of Brighton, Brighton*
Distant Relations, Camden Arts Centre, London; The Irish Museum
of Modern Art, Dublin; Santa Monica Museum of Art
Face a l'Histoire, Centre Georges Pompidou, Paris*
Happy End, Kunsthalle Düsseldorf, Düsseldorf*
ID, Stedelijk Van AbbeMuseum, Einhoven*
Language, Mapping and Power, Orchard Gallery, Derry*
L'Imaginaire Irlandais, Ecole Nationale Superieure des Beaux-Arts
de Paris, Paris*
NowHere, Louisiana Museum of Modern Art, Humlebaek*
The 10th Biennale of Sydney, Sydney*

1997 *Between Lantern and Laser*, Henry Art Gallery, Seattle
Città/Natura, Palazzo delle Esposizioni, Rome*
Dimensions Variable, British Council Touring Exhibition*
Identité, Le Nouveau Museé, Institut d'Art Contemporain, Villeurbanne
Islas, Centro Atlantico de Arte Moderno, Las Palmas*
No Place (Like Home), Walker Art Center, Minneapolis*
Pictura Britanica, Museum of Contemporary Art, Sydney*
Shot – Reverse Shot, Walter Phillips Gallery, Banff
Surroundings, Tel Aviv Museum of Art, Tel Aviv*
Ten Contemporary Photographers, Vaknin Schwartz, Atlanta

1998 *Art from the UK (Part II)*, Sammlung Goetz, Munich*
Critical Distance, Andrew Mummery, London
Eugenio Dittborn, Willie Doherty, Mona Hatoum, Doris Salcedo,
Alexander and Bonin, New York
New British Art, Kunstraum Innsbruck, Innsbruck*
Real/Life: New British Art, Tochigi Prefectural Museum of Fine Arts,
Fukuoka City Art Museum, Fukuoka; Hiroshima City Museum of
Contemporary Art, Hiroshima; Museum of Contemporary Art, Tokyo;
Ashiya City Museum of Art & History, Tokyo*
Wounds: Between Democracy and Redemption in Contemporary Art,
Moderna Museet, Stockholm*

Selected Bibliography

1987 Roberts, John, *Directions Out*, Artscribe International,
September/October

1988 Coppock, Christopher, *Colouring The Black and White*,
Circa Art Magazine, No. 40, June/July

1990 Irvine, Jaki, *Willie Doherty*, Circa Art Magazine, No. 53,
September/October

1991 Doherty, Willie, *They're all the Same*, a project for Frieze, vol. 2
Drier, Deborah, *Same Difference*: a project by Willie Doherty for
Artforum, May
Godfrey, Tony, *Willie Doherty at Matt's*, Art in America, January
Philippi, Desa, *Willie Doherty: Matt's Gallery*, Artforum, January
Scanlon, Patricia, *Outer Space*, Variant, No. 10, Winter

1992 McWilliams, Martha, *Terror to Scale*, New Art Examiner, April

1993 *La Biennale de Venise, XLV Esposizione Internazionale d'Arte 1993,*
 Marsilio, Venice

1994 Blazwick, Iwona, *Willie Doherty*, Art Monthly, No. 172,
 December/January
 Cameron, Dan, *Social Studies*, Art & Auction, November
 Faure Walker, Caryn, *Willie Doherty: Arnolfini, Bristol and Matt's Gallery,
 London,* Portfolio: The Catalogue of Contemporary British Photography,
 Issue 19
 Harvey, *William Willie Doherty: Matt's Gallery*, Untitled, No. 4
 Irvine, Jaki, *The Only Good One Is A Dead One*, Third Text, No. 26,
 Spring
 Kastner, Jeffrey, *Willie Doherty: Matt's Gallery*, London, Frieze, No. 14,
 January/February
 Morgan, Stuart, *The Spine: De Appel, Amsterdam*, Frieze, No. 16, May
 Pepper, Jens, *Matt's Gallery im Londoner East End*, Neue Bildene
 Kunst, 1/94, February/March
 Renton, Andrew, *Willie Doherty: Matt's Gallery*, Flash Art, Vol. XXVII,
 No. 174
 Schaffner, Ingrid, *Willie Doherty: Grey Art Gallery*, Artforum, Vol. 33,
 No. 4, December

1995 Christov-Bakargiev, Pratesi, *Arte Identità Confini*, Carte Segrete, Rome
 Baque, Dominique, *Menaces,* Art Press, No. 203, June
 Kastner, Jeffrey, *Ten Artists to Watch Worldwide: Willie Doherty,
 Northern Ireland*, Artnews, January
 Mac Giolla Leith, Caoimhin, *Willie Doherty, Kerlin*, Flash Art, Vol. XXVIII,
 No. 182, May/June
 Maul, Tim, *Willie Doherty*, Journal of Contemporary Art, Vol. 7, No. 2
 Rowlands, Penelope, *Willie Doherty: Jennifer Flay*, Artnews, Summer

1996 Frankel, David, *Willie Doherty – Alexander and Bonin*, Artforum,
 May/June
 Green, David, *Willie Doherty. Thwarted Vision*, Portfolio, No. 24,
 December
 Heartney, Eleanor, *Willie Doherty at Alexander and Bonin,*
 Art in America, September
 Hand, Brian, *Swerved in Naught*, Circa Art Magazine, No. 22, Summer
 Higgins, Judith, *Report From Ireland – Art at the Edge (Part II)*,
 Art In America, April
 Lanzinger, Pia, *Willie Doherty*, Camera Austria International, No. 56
 Volk, Gregory, *Willie Doherty – Alexander and Bonin*, Artnews, April

1997 Archer, Michael, *Willie Doherty: Matt's Gallery*, Artforum XXXVI,
 November
 Cerrato, Guiseppe, *Irischer Kunst-Reporter*, Schweitzer Illustriert,
 No. 37, 8 September
 Cubbit, Sean, *Willie Doherty*, Art Monthly, No. 208, July/August
 Ireson, Ally, *same old story*, D>tour, July
 Kurjakovic, Daniel, *Willie Doherty in der Galerie Peter Kilchmann*,
 Bulletin, No. 9, September
 Licata, Elizabeth, *Being in Time: The Emergence of Video Projection*,
 Artnews, No. 123, February
 Lores, Maite, *Willie Doherty: same old story*, Contemporary Visual Arts,
 No. 16, Autumn
 Mac Namara, Aoife, *Willie Doherty: Art Gallery of Ontario*,
 Parachute 87, Summer
 Masterson, Piers, *Willie Doherty*, Creative Camera, August/September
 Slyce, John, *Willie Doherty*, Flash Art, November/December

* Catalogue

List of works

(all dimensions height x width)

Fog Ice/Last Hours of Daylight 1985
diptych, each panel 1220 x 1830mm
Black and white photographs with text mounted
on masonite
Courtesy Matt's Gallery, London and
Alexander and Bonin, New York
p 14, 15

Stone Upon Stone 1986
diptych, each panel 1220 x 1830mm
Black and white photographs with text mounted
on masonite
Courtesy Galerie Jennifer Flay, Paris
p 10, 11

The Walls 1987
610 x 1525mm
Black and white photograph with text mounted
on masonite
The Artist
p 19

The Other Side 1988
600 x 1500mm
Black and white photograph with text mounted
on masonite
Private Collection
p 18

Strategy: Sever/Isolate 1989
diptych, each panel 1220 x 1830mm
Black and white photographs with text mounted
on aluminium
Collection Jennifer Flay, Paris
p 34, 35

They're all the Same 1991
Dimensions variable. Duration 3 mins
Slide projection with sound track
Sammlung Goetz, Munich
p 22, 23

The Bridge 1992
diptych each 1220 x 1830mm
Black and white photographs mounted
on aluminium
Private Collection
p 20, 21

Enduring 1992
1220 x 1830mm
Black and white photograph with text mounted
on aluminium
Private Collection

Incident 1993
1220 x 1830mm
Cibachrome print mounted on aluminium
Collection Robin Klassnik

At the End of the Day 1994
Dimensions variable. Duration 10 mins
Video installation with sound track
Arts Council Collection
p 30, 31

Border Road II 1994
1220 x 1830mm
Cibachrome print mounted on aluminium
Courtesy Matt's Gallery, London and
Alexander and Bonin, New York
p 40, 41

*At the Border I (Walking towards a military
checkpoint)* 1995
1220 x 1830mm
Cibachrome print mounted on aluminium
Courtesy Matt's Gallery, London and
Alexander and Bonin, New York

At the Border III (Trying to forget the past) 1995
1220 x 1830mm
Cibachrome print mounted on aluminium
Courtesy Matt's Gallery, London and
Alexander and Bonin, New York

At the Border VI (Checkpoint) 1995
1220 x 1830mm
Cibachrome print mounted on aluminium
Courtesy Kerlin Gallery, Dublin

Bullet Holes 1995
762 x 1016mm
Cibachrome print mounted on aluminium
Collection Jennifer Flay, Paris

Tunnel 1995
1220 x 1830mm
Cibachrome print mounted on aluminium
Collection Harry Handelsman

Uncovering Evidence that the War is Not Over I
1995
762 x 1016mm
Cibachrome print mounted on aluminium
Courtesy Kerlin Gallery, Dublin
p 36

Uncovering Evidence that the War is Not Over II
1995
762 x 1016mm
Cibachrome print mounted on aluminium
Courtesy Kerlin Gallery, Dublin
p 37

Disclosure I (Restricted Access) 1996
1220 x 1830mm
Cibachrome print mounted on aluminium
Courtesy Matt's Gallery, London and
Alexander and Bonin, New York
p 38, 39

The Fence 1996
1220 x 1830mm
Cibachrome print mounted on aluminium
Collection Marie and Joe Donnelly, Dublin

Tell Me What You Want 1996
Dimensions variable. Duration 10 mins
Two monitor video installation
Courtesy Matt's Gallery, London
p 28, 29

Abandoned Interior II 1997
1220 x 1830mm
Cibachrome print mounted on aluminium
Courtesy Matt's Gallery, London and
Alexander and Bonin, New York
p 32

Abandoned Interior III 1997
1220 x 1830mm
Cibachrome print mounted on aluminium
Courtesy Matt's Gallery, London and
Alexander and Bonin, New York
p 33

Border Crossing 1997
1220 x 1830mm
Cibachrome print mounted on aluminium
Courtesy Matt's Gallery, London and
Alexander and Bonin, New York

Critical Distance 1997
1220 x 1830mm
Cibachrome print mounted on aluminium
Courtesy Matt's Gallery, London and
Alexander and Bonin, New York
p 12, 13

No Visible Signs 1997
1220 x 1830mm
Cibachrome print mounted on aluminium
Courtesy Matt's Gallery, London and
Alexander and Bonin, New York
p 6

The Road Ahead 1997
1220 x 1830mm
Cibachrome print mounted on aluminium
Mourne Country Collection

Small Acts of Deception I 1997
diptych
1220 x 1830mm
1220 x 1220mm
Cibachrome print mounted on aluminium
Courtesy Matt's Gallery, London and
Alexander and Bonin, New York
p 24, 25

Black Spot 1997
Dimensions variable. Duration 30 mins
Video installation
Courtesy Matt's Gallery, London
p 17

Somewhere Else 1998
Dimensions variable. Duration 30 mins
Four screen video installation with soundtrack
Courtesy Matt's Gallery, London
Commissioned by the Foundation for Art and
Creative Technology and funded by the National
Lottery through the Arts Council of England and
the Henry Moore Foundation in association with
the 9th International Symposium of Electronic Art
(isea98).
Inside front cover, p 1, 2, 3, 50–57, 64 and
inside back cover.

This exhibition, financially supported by Tate Friends Liverpool and in association with the Foundation for Art & Creative Technology,
is presented as part of revolution98 for the 9th International Symposium on Electronic Art (isea98) in Liverpool and Manchester

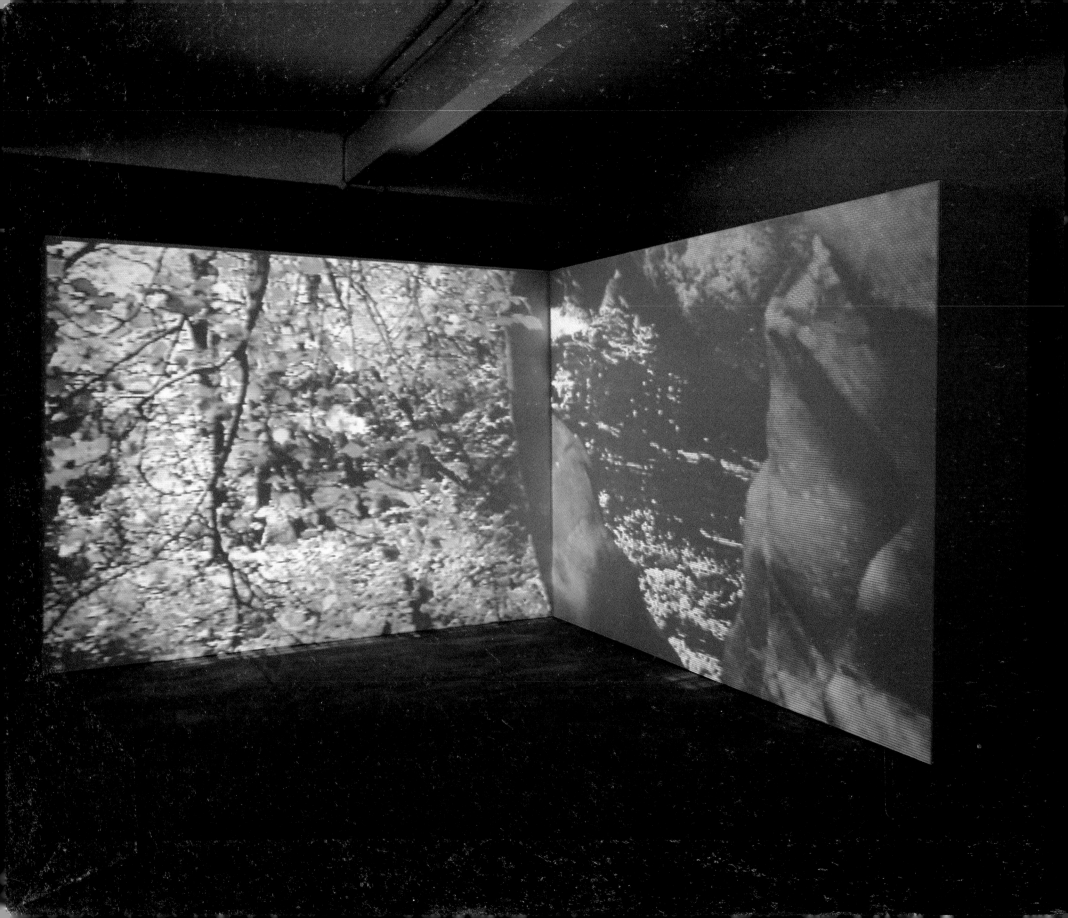